Tea with Jesus and Me

Stories of God's Faithfulness

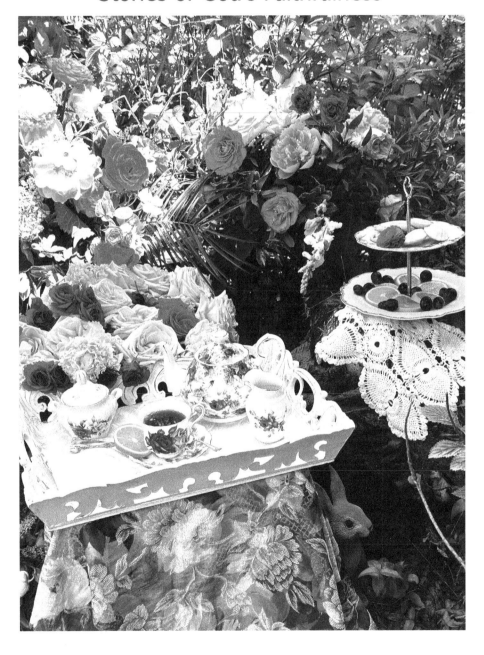

Sherri House

Published by:

Tea Garden Publications
18896 Greenwell Springs Road
Greenwell Springs, LA 70739
www.thepublishedword.com

Case Laminate Edition ISBN 978-1-950398-93-5
Trade Paper Edition ISBN 978-1-950398-92-8
eBook Edition ISBN 978-1-950398-94-2

Printed on demand in the U.S., the U.K., Australia and the UAE
For Worldwide Distribution

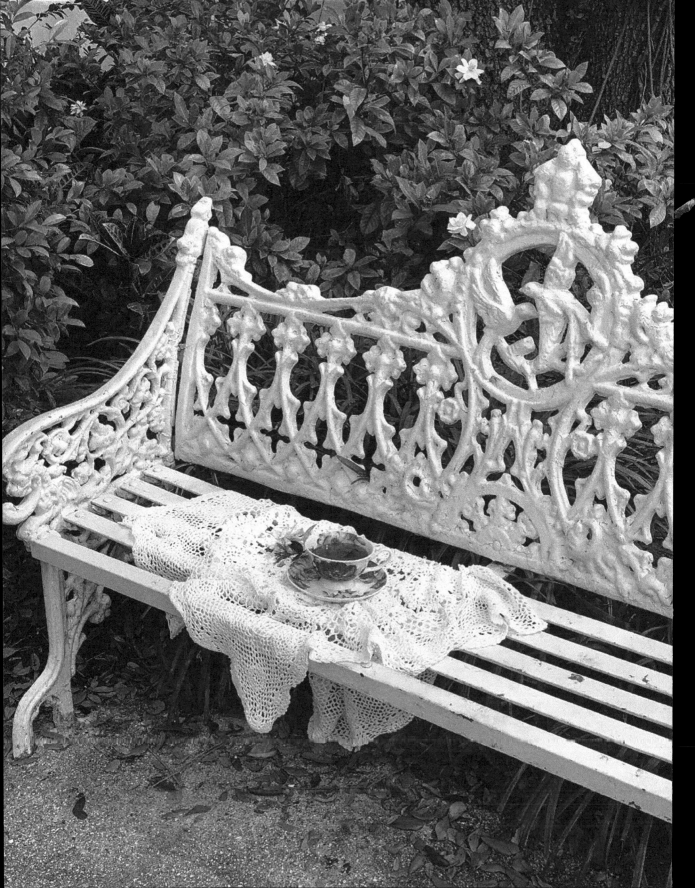

Endorsements for
Tea with Jesus and Me

"Someone once said the mind of a follower of Christ is a brand-new canvas every morning, ready to capture the splendor and majesty of our Creator. There are those who know how to take the brush and gracefully paint the beauty and reveal a greater dimension of the Creator's heart towards us on that canvas. I'm describing the gift and abilities of Sherri House. Her choice words, sentences, and even images showcased in her writings soothe the inner soul, quiet the noisy clamor that comes from our world, and reminds the heart of the reader that our God is nearer than we could ever imagine. Sherri's gift in writing comes from her authentic desire to hear, see, and know God. You will be drawn closer to the One that brings her inspiration. Slow down, grab your favorite teacup and saucer, and let your heart's canvas imagine the stories and encouragement this book will share."

Rev. Dr. Randall Holdman
Sr. Pastor, Parkway Life Church
Naples, Florida

"In Tea with Jesus and Me, you will find true life stories filled with hope, love, and faith, encouraging you and all who read to trust in a living God who never fails. One of the chapters in this book, "When He Speaks- Listen," will help you know the voice of God and how to follow Him. Sherri writes remarkable true stories infused with real-life experiences of God's love and hope-filled faith! She brings life in Christ alive as an adventure from mountain heights to valley's low experiences, yet victory in them all!"

Rev. Sheila Zellers
Motivated by Love Ministries Inc.

"Sherri has a keen sense for hearing the voice of God, and He used her writings to encourage and help me find my true passion and purpose. Sherri and I served together in ministry for fifteen years at Parkway Life Church. When together, I have always felt enriched in my heart, increased in faith, and emboldened in courage. Her spirit is always comforting, and that gift shines brightly through her writings.

"This book carries an anointing to touch and bring healing and purpose to women everywhere. So, position your heart and get ready to hear God's voice speaking to you as you read Sherri's beautiful "Tea with Jesus and Me" devotional."

Ana Stevenson
Founder/President
Path2Freedom Inc.

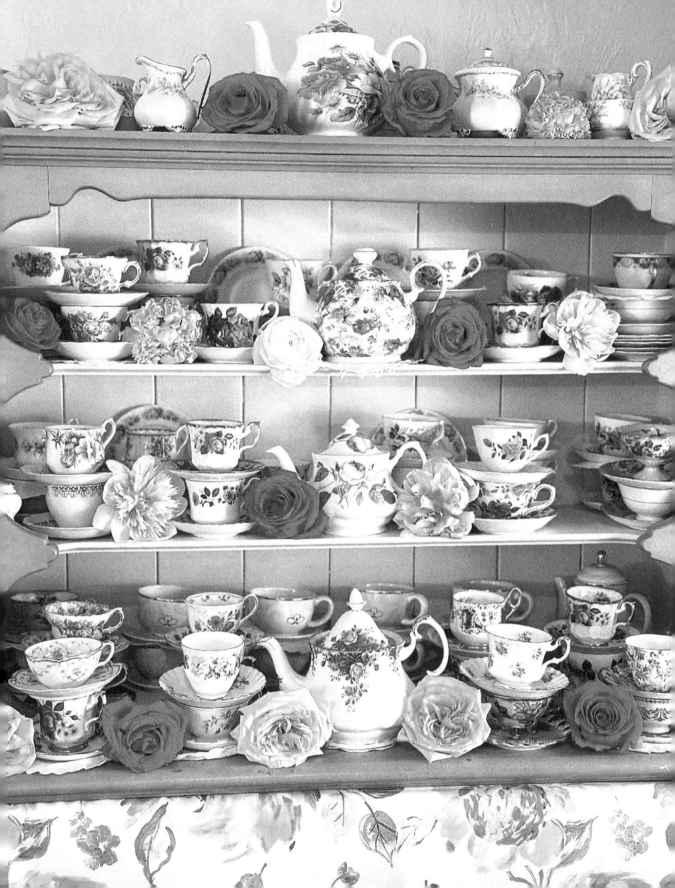

Dedication

I dedicate this book to the greatest treasure God has given me on this Earth,
my beautiful and loving family:

To my tenderhearted and faithful husband of 51 years, Mark, my love, you are my everything. You have always been by my side as my strength and support with unconditional love, always encouraging me to be all that God calls me to be. I am so blessed that you are the one who walks through life with me proclaiming God's faithfulness.

To my three anointed and gifted children that I am so proud of and love so dearly—Brian, Tamara, and Janelle—and your incredible spouses Carissa, David, and Richard, whom I love like my own, and to the grandchildren God blessed us with—Emily, Daniel, Josiah, Alyssa, Arianna, and David. You are all my delight and my joy. Each of you blesses me by the upright and godly lives you live and how you honor me and have encouraged me in this endeavor. The fertile soil of your hearts has received the seed of His Word and produced a bountiful crop to the praise of HIS glory.

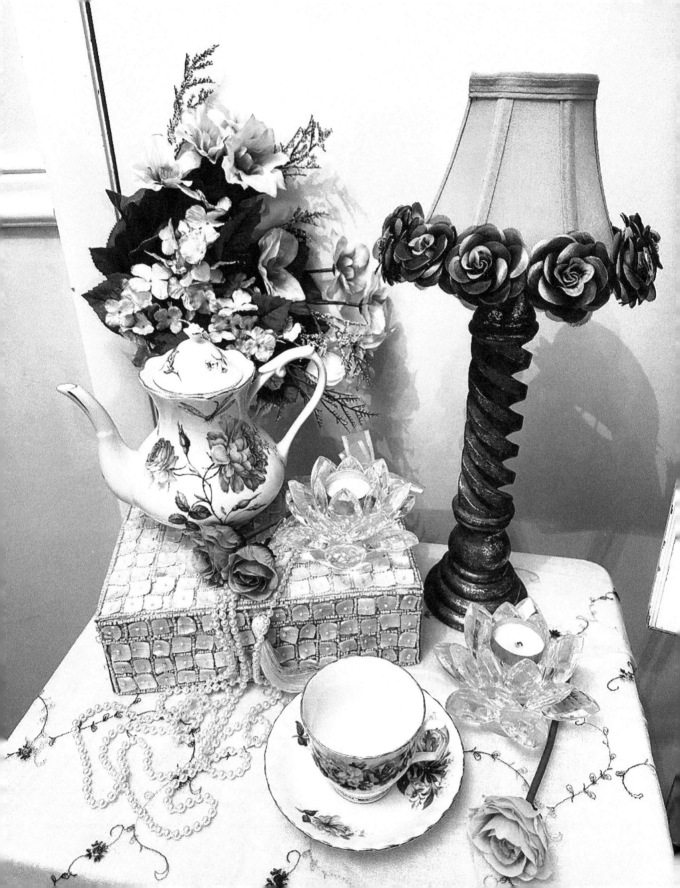

Acknowledgments

One cannot embark on a journey like this without having been impacted by many people along the way. Just like the vast array of artistic beauty seen in different teacups, each one of these people have imparted a portion of their gifts into my life, enabling me to produce this book.

First, I must acknowledge the One to whom I owe both my physical life and my eternal life, the One to whom I desire to give all glory and all praise, my Lord and Savior Jesus Christ, and the Holy Spirit who indwells me, sustains me, and shows me the wonders of our Heavenly Father's mighty love and faithfulness of which I write.

Acknowledgment must be given to my mother in Heaven. I honor her. She trusted our Savior and is the one who instilled in me the ability to see beauty and creativity in the little things.

I want to thank the spiritual leaders and mentors who have prayed with me, imparted biblical truth into my life, and supported me to write all the wonderful things God places on my heart.

My pastor, Randall Holdman, who has been a constant encourager for me to step out with my writing.

Ana Stevenson, who mentored me in leadership and spoke words over me that propelled me into action.

My friend, Teresa Hammons: for all your cheerleading, proofreading, and pre-editing.

Brian House, my amazing and gifted son: thank you for your technical assistance, advice, and computer support when I needed it.

Carissa House: thank you for your joyful encouragement, for loving me enough to stomp through a horse field to set up tea with me, and for being willing to stop what you were doing when I needed your keen eye.

Tamara Grundy, my passionate and giving first-born daughter: thank you for your cheerful exhortations reminding me to share what God has imparted to my heart, for the teatimes we shared together in this book and for your prayers and encouragement that have meant so much to me.

Janelle Varnes, my precious talented daughter: thank you for your loving help in so many ways, for your very wise suggestions and photo input, and for having fun with me carrying tea things onto the boat for tea photos. Your help and encouragement have been a loving gift on this journey.

Justin Ellis of jpegdesign, who patiently helped me perfect my cover photo.

My publishing partners, Harold and Andy McDougal: your hard work helped me accomplish a lifelong goal. Thank you.

The artist of the Jesus Pouring Tea painting, Carol Weaver: thank you for blessing me with the rights to use your original painting, Fill My Cup, Lord.

And to many others, too many to name, who have enjoyed afternoon teatime devotions with me.

Contents

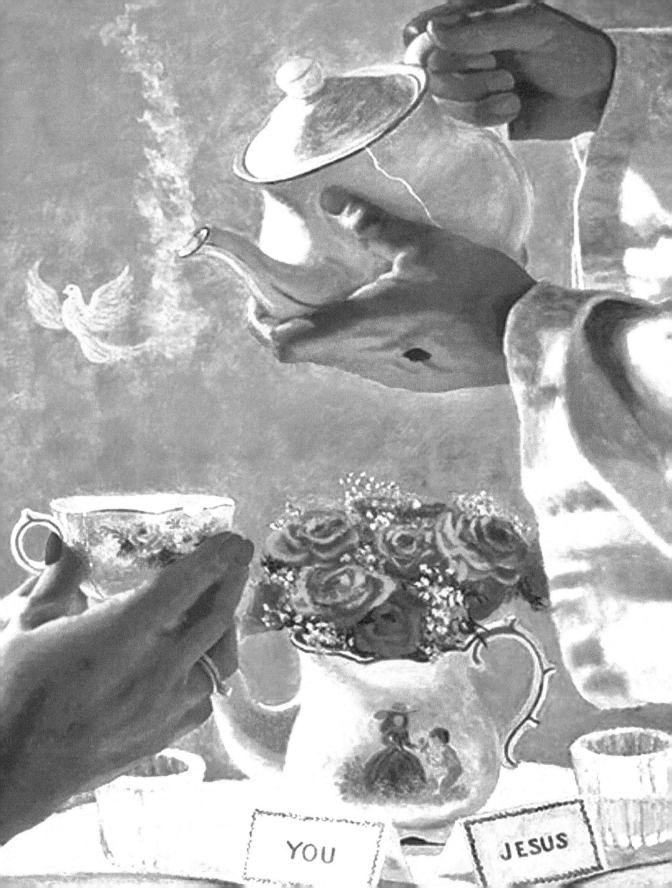

Introduction

What if you could hold up your teacup and have Jesus pour for you? What if, with every pour, the Holy Spirit infused you with His love and His truths? This is what *Tea with Jesus and Me* is all about. Here you will enjoy lovely teatimes and read true stories that will build your faith. You will see how God longs to talk to you, and, in fact, does talk to you every day, in many ways, and how, by sharing even the simplest events from your own life, you can pass the seeds of faith to the next generation.

The desire to share true stories with you during teatime came while I was having my afternoon tea, and, at the same time, reading my Bible and having devotions. The words of the chorus to a hymn of the previous century came to mind: *"Fill my cup, Lord; I lift it up, Lord. Come and quench this thirsting of my soul."*[1] I want to lift the cup of my heart to the Lord and have Him fill me with His Holy Spirit every day, and if you picked up this book, then you do too. I invite you to join me for teatime and devotional stories. Pour yourself a cup of your favorite tea. Get your favorite cookie or teacake, and be sure to have your Bible ready.

Each time we visit we will have tea in different beautiful locations. During our teatime, I will be sharing interesting stories and scriptures that enlighten the wonderful ways our Savior can reveal Himself to us through the everyday events of our lives. I want you to catch the exciting truth that sharing the ways God speaks and reveals Himself to us through our daily experiences is one way we can pass our faith on to the next generation.

It's not just about my stories; it's about yours too. You have stories to tell, stories of how God showed Himself faithful in your life, stories of how He answered prayer or rescued you from disaster, stories that, if told, can be your way of sowing the seeds of faith in God to the next generation. While enjoying our teatime devotions together, it is my heart's desire to fill you with excitement to do just that!

Together we will visit interesting and, at times, unusual locations to enjoy afternoon tea. We will have tea in a garden, on a boat, at historical landmarks, or out in a big open field. We might even carry our three-tier server out into the woods and enjoy our tea and devotions amidst autumn foliage, while listening to the leaves fall and watching the deer. I will be sharing teatime treats, tea selections, and afternoon tea table decor with you. After each teatime, I will share a true story that I hope will ignite your heart to see the many ways God speaks to you of His love and motivate you to share your own stories of God's faithfulness in your life.

Our teatimes, in this book, are about a sense of togetherness, chatting over tea or coffee, if you prefer, and sharing how our Lord talks to us and reveals Himself to us every day and shows us His love in many creative ways. My purpose for sharing these personal and intimate stories from my life is to help you to be aware of all the marvelous ways God can speak to you in your own life.

It's not just about my stories; it's about yours too! I desire to help you look at the moments that make up your day and have eyes to see that God speaks to you in the midst of them. No one need ever say, "I don't know how to hear God's voice," for indeed, He speaks to you of His love and faithfulness every day in so many ways.

So put the kettle on and find your place at the table. The seeds of faith are about to fly, and teatime with Jesus, and you, and me is about to begin.

— *Sherri House*

1. Words and music by Richard Blanchard (1925-2004)

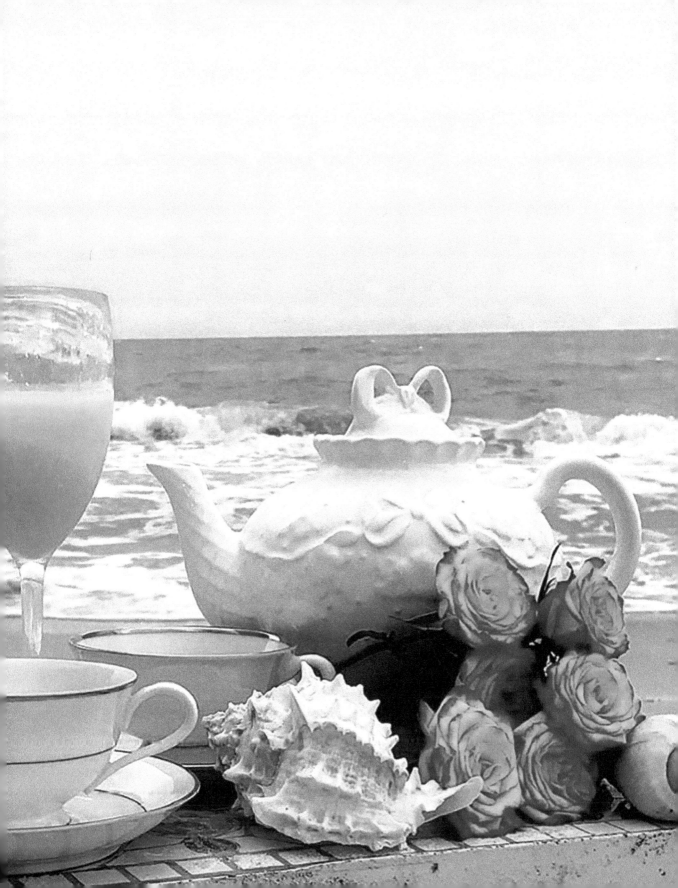

Tea at the Beach

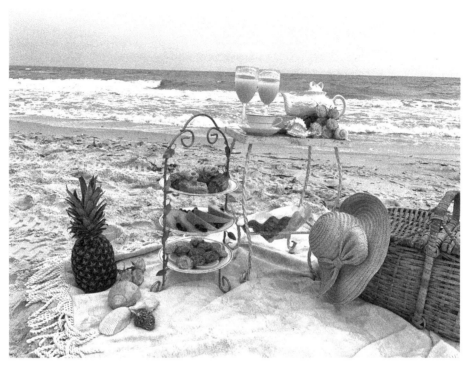

Today I'm going to take you on a beach outing for tea. We are packing our picnic basket with a lovely porcelain teapot and teacups, along with some tantalizing food, and heading to the white sandy beaches of the Gulf of Mexico for a Sunday brunch.

It's already in the 90s this morning, and a storm is brewing in the distance. The waves are rough, and the wind is really whipping up as we spread our blanket near the shore. I would love to have you join me as we put a fresh pineapple on one corner to hold the blanket down and set our picnic basket and sun hat on the other corner.

The seagulls are loudly calling to one another and circling overhead as we start loading our three-tier server with delights. Luckily, a school of small fish started jumping offshore, distracting these flying and swooping thieves, so they quickly left our picnic area.

If we weren't hungry when we arrived, we surely are now, as we set up the bottom tier with still-warm egg frittatas and freshly-sliced oranges. The oranges smell so good I can hardly wait to eat. Cool, ripe cantaloupe and blueberries grace our middle tier. The top tier holds vanilla crumb coffee cake and raspberry swirl pastries garnished with strawberries. Is your mouth watering yet?

Fresh orange juice in stemware, and English Breakfast tea in this beautiful white teapot will quench our thirst. Don't you love these roses we brought with us to put on our table? They glow like a sunrise next to the beach shells. All we have to do now is stretch out, inhale the sea breeze, and relax. Please pass the cantaloupe.

The sun has been warm and relaxing, and after all that food, it's tempting to fall asleep. So, let's get up and walk on the sand for a while. Tiny shells glisten in the sunlight, and clumps of seaweed wash onshore, as the cool waves break over our feet. It's really rough out there, and the waves are churning loudly. No matter what the weather, something about a walk on the beach causes thoughtful reflection.

Don't these restless waves remind you of the story in Mark 4:37-40 when Jesus calmed the storm? Most of us sense a storm brewing in our world, and all of us need peace right now. So, come with me. Let's talk while we walk along the shore together. I have a true story to tell you.

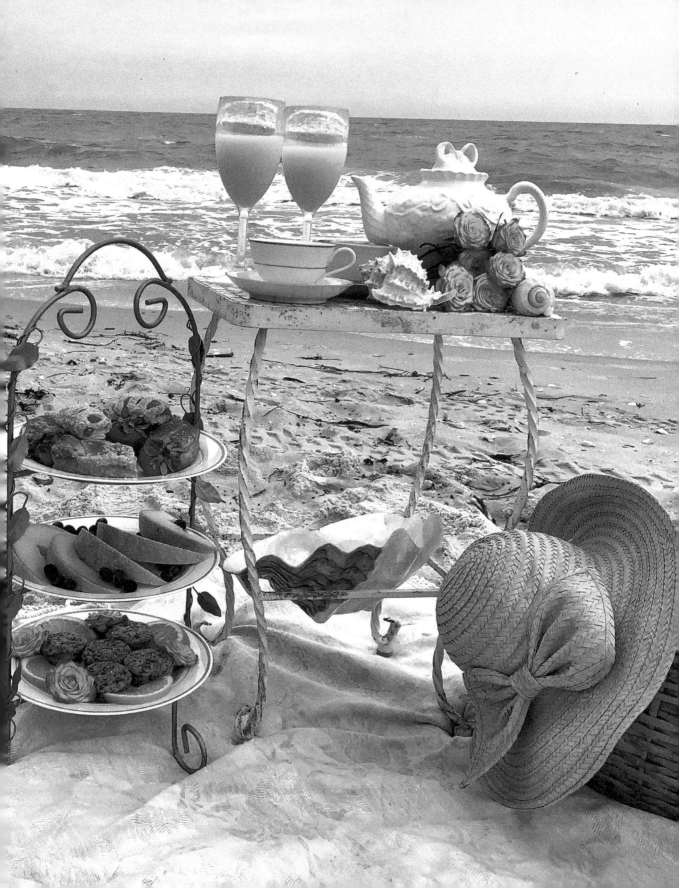

Peace, Be Still
Devotion

For God has not given us a spirit of fear,
but of power and of love, and of a sound mind.
— 2 Timothy 1:7, NKJV

The day was calm and sunny, so my husband decided to take our 17-year-old son fishing. He knew that Hurricane Andrew was 48 hours from us and headed our way, but he said the tide was perfect for fishing and promised they would be back in just a few hours. Packing their food and the mandatory sweet tea, I found myself having to pray away a strange sense of apprehension flooding over me.

They had taken our 14-foot McKee Craft out to fish in the mangroves of the backwaters many times before, so as I watched them load the boat with poles and tackle, I told myself not to worry. My husband and 3 generations before him have always lived in this area. He was raised to be familiar with all the twists and turns of our vast and remote 10,000-island waterways. "I have nothing to worry about," I reassured myself.

They left early morning, and when they weren't back by lunch, I calmly prayed. When dinner time came and darkness was closing in, that storm out in the Atlantic was no match for the storm that started churning inside of me. No matter how hard I prayed, no matter how

hard I trusted, my apprehension grew. It was 1992, and cellphones were not yet commonplace, so I had no way to contact them.

I tucked my preteen daughters in to bed with a kiss and a bedtime prayer, not revealing my apprehension. As the night progressed, long hours of floor pacing began, as I vacillated between faith and fear. It was an internal storm like I had never experienced before. The two most important men in my life were out in the backwaters of the Gulf of Mexico, and there was a hurricane coming. Were they in danger? Should I do something? What could I do?

Sometime after midnight, after hours of praying and watching the news reports of the storm getting closer, I called our pastor, waking him up and telling him the situation. His wife immediately came over to pick up the sleeping girls and take them to their home, while my pastor suggested that I call the Coast Guard. When I described the situation to the Coast Guard officer, he suggested that I meet them at the boat dock my husband used. Our pastor drove me there as I tried to remain calm. I needed my life-long faith in God to sustain me as we drove to the dock.

The mangrove area is vast, and I was the only one who knew where they usually fished, but I couldn't describe the spot to the officers. So, upon meeting them, I asked if I could go along to guide them. Their reply increased the storm inside of me a thousandfold. The Coast Guard officer said, "Ma'am, there's no telling what we might find. So it's best if you don't come." Now, let me tell you what: I am a woman of faith, but that remark intensified the storm that was already churning inside of me.

I was experiencing a storm that only Jesus could calm. I had to let go of fear. I had to allow my Lord to speak "peace, be still" to my soul.

Peace I leave with you; my peace I give to you
Let not your hearts be troubled, neither let them be afraid.
—John 14:27, ESV

It was hours later, just before daylight, when a small boat approached the dock. I let out a sigh of relief as I realized it was my husband. He explained how the approaching hurricane had caused the tides to be stronger than usual. They were having a grand time fishing, but the boat got stuck in the mud of the mangroves at low tide, so they had to wait for the tide to change and bring enough water to float the boat out. My son excitedly relayed seeing a Coast Guard helicopter circle over their boat and how he had exclaimed, "Dad, look! Mom called the Coast Guard on us." Evidently the night was a whole lot more fun for them than it was for me!

In the Bible, Mark 4 gives an account of a storm, not just in the water, but a storm within the disciples' minds and hearts that most of us can relate to.

The disciples were in a boat with Jesus and *"a furious squall came up, and the waves broke over the boat, so that it was nearly swamped. Jesus was in the stern, sleeping on a cushion. The disciples woke Him and said to him, 'Teacher, don't you care if we drown?' He got up, rebuked the wind and said to the waves. 'Quiet! Be still!' Then the wind died down and it was completely calm. He said to his disciples, 'Why are you so afraid? Do you still have no faith?'"* (Mark 4:37-40, NIV).

For the disciples, that moment was double trouble. Not only was there a real storm buffeting them, but they had a storm of fear inside their hearts. That internal storm may have been their biggest threat. Why? Because their fear was hindering their faith.

Think about it: Jesus was right there with them. They had the Creator of the entire Universe in the boat with them. They had seen Him perform many miracles. They knew Him, and yet they still battled with fear in the midst of the storm.

Sound familiar? Do you love the Lord, know Him, have Him in your life, and yet still find yourself getting fearful in the storms of life? Perhaps the storm you're battling right now is a financial one, a family situation, or a health issue. Maybe you're frightened by the storm brewing in the world, and you find yourself asking the same question the disciples did: "Lord, don't you care that we are perishing?"

My friend, fear and faith can't be in the boat at the same time. I've tried it, and it doesn't work.

The night I paced the floor, praying, but also vacillating between faith and fear, was an eye-opening spiritual lesson. The Holy Spirit wants to speak "Peace, be still" to our souls, but we must not let our fears shout louder than His words. He has given us His Word, and His promises will calm a fear storm and allow faith to rise in our souls.

"Be strong and courageous. Do not fear or be in dread of them, for it is the LORD your God who goes with you. He will not leave you or forsake you" (Deuteronomy 31:6, ESV). *"Have I not commanded you? Be strong and courageous. Do not be frightened, and do not be dismayed, for the LORD your God is with you wherever you go"* (Joshua 1:9, ESV).

"Fear not, for I am with you; be not dismayed, for I am your God; I will strengthen you, I will help you, I will uphold you with my righteous right hand …. I, the LORD your God, hold your right hand; it is I who says to you, "Fear not, I am the one who helps you" (Isaiah 41:10-13, ESV).

Then He arose and rebuked the wind, and said to the sea, "Peace, be still!" And the wind ceased and there was a great calm.

–Mark 4:39, KJV

19

It is always an honor to share my experiences of God's goodness with you, but the purpose of our teatime devotions is not just about my stories; it's about yours too.

Give thought to times that you were fearful and you experienced the comfort of the Holy Spirit of God through that time. Tell your story, and share your legacy of faith with the next generations.

PRAYER: Heavenly Father, thank You that You never leave me or forsake me. Thank You that You have given me Your precious promises to lean on. Help me to bank Your words in my heart so that when the waves of life start crashing, I will hear Your voice louder than the storm.

CALL TO ACTION: Memorize one or several of the scriptures above or below or whatever scripture God has spoken to your soul, reassuring you of His presence in the midst of your storm.

FOR FURTHER ENCOURAGEMENT: Psalm 46:10, James 1:6, Hebrews 11:6, Hebrews 11:11, and Romans 15:13.

Write here something of God's faithfulness to your life:

Be still, and know that I am God;
I will be exalted among the nations,
I will be exalted in the earth!

– Psalm 46:10, NKJV

And without faith it is impossible to please God,
because anyone who comes to him must believe that he
exists and that he rewards those who earnestly seek him.

–Hebrews 11:6, NIV

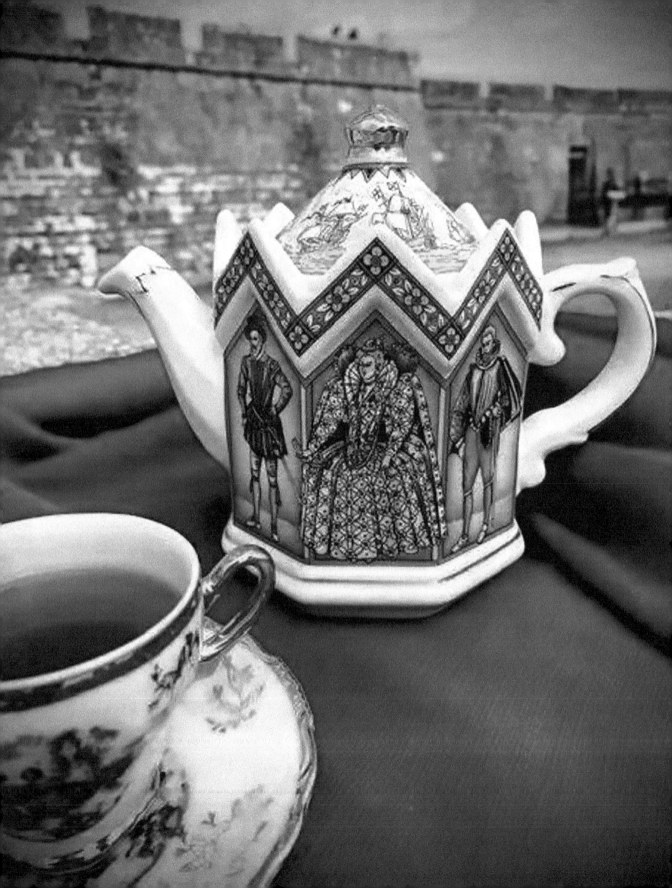

Tea at the Fortress

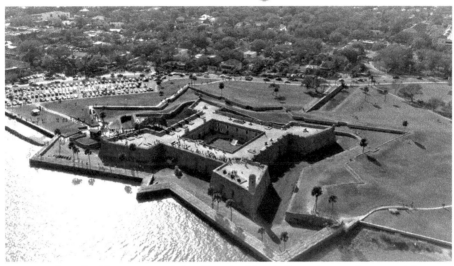

oday you need to buckle your seat-belts. I'm going to take you on a virtual trip to St. Augustine, Florida. We are going to a very unusual location for setting up afternoon tea, but let's think outside of the box and have an adventure.

The site of our afternoon teatime devotions will be at a massive old fortress built in 1672, the Castillo de San Marcos, which sits right along the waterfront. As we approach the fort, it looks like it should be in a European country. It is definitely not something you would expect to see when visiting Florida. This huge fort is shaped like a star, with four watchtower projections. It covers several acres of land, so it takes a bit of walking to find a spot to set up our tea. The sky is brilliantly blue on this beautiful day, and there is plenty of grass at the bottom of the hill around the fort, so I decided to spread a tablecloth on the grass beside one of the lookout towers.

For our afternoon tea today, we will enjoy a simple selection of fresh bread, fruit, and veggies. Of course, we have to indulge in a decadent dessert, so you have your choice of dark chocolate brownies or lemon layer cake with raspberry filling. I can almost hear all of you exclaiming how hard it is to eat your veggies first when a chocolate brownie stares you in the face.

The history of this unusual afternoon tea location calls for a very unusual teapot, and I brought along the perfect one. This teapot depicts Queen Elizabeth I of England, surrounded by Sir Walter Raleigh, Sir Frances Drake, and Robert Dudley, the Earl of Leicester. The lid of the teapot has paintings of old

ships similar to the ones that crossed the seas and approached this fortress with cannon fire.

As we pour a cup of orange-infused black tea, my daughter Tamara tells us a little bit about the history of this massive fortress and the walls around us. We learn that it is made of coquina shells and was built in 1672 by the early Spanish settlers. The Spanish-held fort came under fire in 1702 by British forces, but the coquina shell made it impenetrable to their cannon fire. We can still see some of the cannonballs embedded in the walls.

Years later, in 1763, this area became a British colony for a 20-year period of English rule, and then it bounced back and forth between Spanish and British rule until the United States acquired Florida in 1821. The Castillo Fort was used as a military prison during the Revolutionary War, and at one time it held three signers of the Declaration of Independence within its walls. Such history! If only walls could talk!

This grassy spot has been relaxing, but let's pick up our server and teapot and head closer to the moat retaining wall, to finish enjoying our tea. The more I look at these walls, the more I begin to think about all the walls mentioned in the Bible, especially the familiar Bible story about the walls of Jericho.

My friend, pour yourself another cup of tea and find a seat on the wall next to me. Are you ready for our teatime devotions? As the wind blows and we sip our tea, I know that the Holy Spirit can speak to us here. So, grab your Bible and go with me to the book of Joshua.

Name Your Wall
Devotion

"Worship Your Way to Victory"

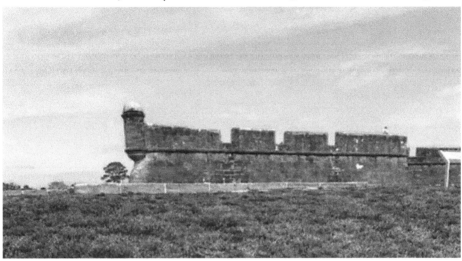

As a young bride in the 1970s, building our first home was a dream come true. We were only in our twenties at the time, and we both worked all day, but each afternoon my husband drove to our property and continued working long hours into the night building our home. Since we were doing all the work ourselves, it took us months to clear the land and lay the foundation and several years to complete the full house.

Every weekend we drove together to the property to check on the progress. In the beginning, all I could think about was, "When will I see the walls going up?" For some reason, in my mind, it just wouldn't be a house until I could see walls. Even when the exterior concrete block walls were up, I still anticipated the building of the interior walls. I viewed them as protection, and those walls were important to me.

What comes to your mind when you think about a wall? God used walls several times in the Bible to show us His ways and teach us His truths. In the book of Nehemiah, God spoke about the building of a wall. But in the book of Joshua, God tells us about another wall, one that didn't need to be built, but, instead, needed to be knocked down. Today, as we have tea by the wall of this fortress, let's talk about the walls of Jericho.

There are so many ways to view a wall. Walls protect, but walls can also limit. The Cambridge Dictionary defines a wall as "a mass formed in such a way that you cannot get through it, or past it." This means that a wall can keep us from something important or wonderful on the other side.

Imagine what the Israelites thought when they knew there was a promise for them, but God told them they had to take the city of Jericho first, and it was surrounded by tall walls. According to archaeological findings, the walls of Jericho were 4 to 6 feet thick and 13 feet tall. They also had several watchtowers, each about 28 feet tall. I imagine when the Israelites saw those formidable walls of Jericho, they felt frustrated at the seemingly-impossible task and wondered how they could get through it. Not only that, but God had given them instructions that didn't seem to make sense.

Adobe Stock Photo

"Now, Jericho was securely shut up because of the children of Israel; none went out, and none came in. And the LORD said to Joshua: 'See! I have given Jericho into your hand, its king, and the mighty men of valor. You shall march around the city … ; you shall go all around the city once. This, you shall do six days. And seven priests shall bear seven trumpets of rams' horns before the ark. But the seventh day you shall march around the city seven times, and the priests shall blow the trumpets. It shall come to pass, when they make a long blast with the ram's horn, and when you hear the sound of the trumpet, that all the people shall shout with a great shout; then the wall of the city will fall down flat. And the people shall go up every man straight before him'" (Joshua 6:1-5, NKJV).

By faith the walls of Jericho fell down after the Israelites had marched around them for seven days.

–Hebrews 11:30, NASB

During the long repetitive days of walking and waiting, they had to practice courage. Don't think it wasn't hard to keep walking around the wall during that time. They were doing the same thing the same way and not seeing results. All they could rely on was God's word to them. They had to practice faith, endurance, and patience. God knew this, so He told them to take the Ark of the Covenant with them to continually remind them that they were not alone; the Lord was with them.

The silence must have been the hardest part. It made no sense to keep silent in the face of the enemy and the massive wall looming before them. Think about it: reacting to a difficult situation with silence is not natural to our human nature. We tend to want to complain about the problem, come to our defense, and speak our mind. Perhaps that's why God wanted them to remain silent. He needed to quiet their minds and hearts long enough so that they could hear His voice when He told them that it was finally time to open their mouths and claim VICTORY!

The time came, they shouted their praises, and the walls fell. My friend, I want you to stop for a minute and do something. **Name your wall.** Name that thing looming large that feels like an impenetrable wall, keeping you from going forward into the life you know God has promised you.

Your wall might be a long-standing health problem. Maybe your wall is a financial challenge, a relationship obstacle, a family problem, or a God-given vision that you can't seem to walk into.

Yes, I know, not every heath problem is healed. I've been dealing with a health issue since childhood. Not every relationship problem gets rectified quickly either, but whatever your wall is, it doesn't have to keep you from the fullness of life that God has for you.

How do we get past the wall and walk into the promise? Quiet your heart. Be still and silent for a while, and listen to God's Word. I believe we need to follow the same formula that the Israelites did when facing the wall of Jericho. Quiet your heart. Be still and silent for a while. Put one foot in front of the other, keep walking, and listen for God's voice. Hear Him speak to your heart. Know that He is working on your behalf. You don't have to do it yourself. As you worship Him and trust Him, His power is released, and He will be the One to bring those walls down.

"Have not I commanded thee? Be strong and of good courage; be not afraid, neither be thou dismayed: for the Lord *thy God is with thee…"* (Joshua 1:9, KJV). *"I have told you all this so that you may have peace in me. Here on earth you will have many trials and sorrows. But take heart, because I have overcome the world."* (John 16:33, NLT). *"Finally, my brethren, be strong in the Lord and in the power of His might"* (Ephesians 6:10, NKJV).

I think the story of the walls of Jericho falling down is a story of trusting God when things don't make sense. It's a story of God's continuous presence and His constant faithfulness when we obey His Word. It reminds us that God wants us to praise Him for who He is and wait on Him to do what we cannot do ourselves. It's a story that tells us to have faith! *"By faith, the walls of Jericho fell down after they had been encircled for seven days"* (Hebrews 11:30, NASB).

My precious friend, keep walking! Keep walking your faith walk. Keep praising God in the midst of your difficulty. When God tells you, open your mouth and shout out His promises, and that thing that looms in front of you will fall in the presence of the Lord God Almighty!

For we walk by faith, not by sight.
– 2 Corinthians 5:7, ESV

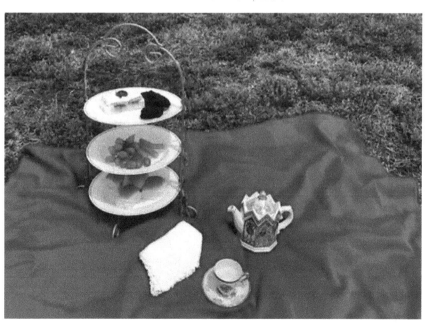

29

The Lord is my strength and my shield, in Him my heart trusts, and I am helped; my heart exults, and with my song I give thanks to Him.
– Psalm 28:7, ESV

PRAYER: Heavenly Father, this is a hard one. Sometimes we feel like we are walking around the same wall and nothing happens, but we will continue to trust in You. We will continue to worship You, because You are faithful, and Your Word is true. Send Your Holy Spirit to strengthen us while we wait on You to do what we cannot do ourselves. We love You, Lord. We trust You, Lord. Amen!

CALL TO ACTION: Keep walking. Put one foot in front of the other and meditate on God's promises. Keep your eyes on Him, not on the wall.

FOR FURTHER ENCOURAGEMENT: Psalm 46:10, 1 John 5:4, Romans 8:31-32, 1 Corinthians 15:57, Psalm 20:7, Psalm 56:3, and Proverbs 3:5-6.

Write here something of God's victories through your worship:

Be still, and know that I am God;
I will be exalted among the nations,
I will be exalted in the earth!
– Psalm 46:10, NIV

But thanks be to God!
He gives us the victory
through our Lord Jesus Christ.
– 1 Corinthians 15:57, NIV

Everyone born of God overcomes the world.
This is the victory that has overcome the world,
even our faith.
– 1 John 5:4, NIV

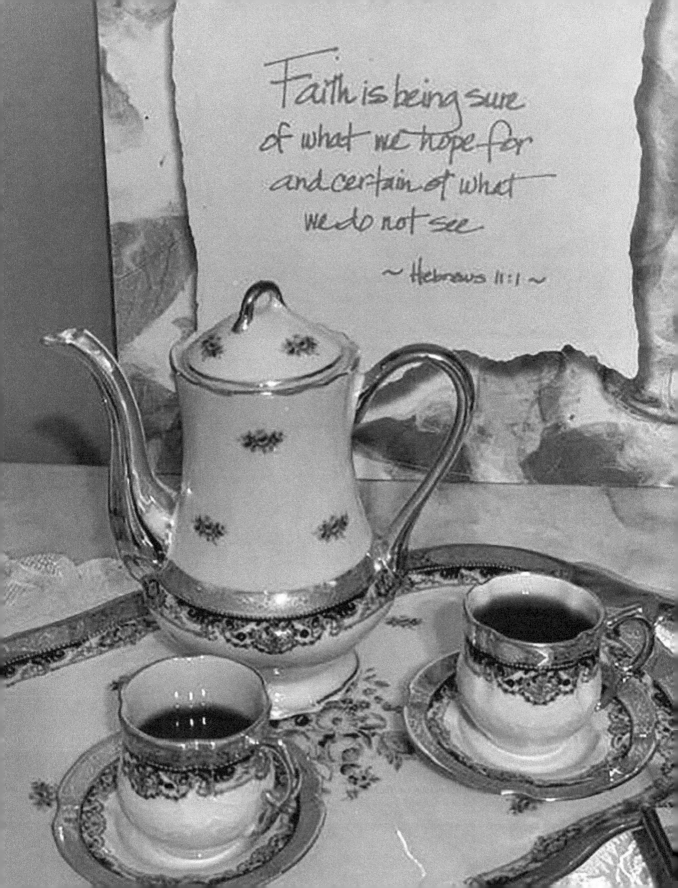

Faith is being sure
of what we hope for
and certain of what
we do not see

~ Hebrews 11:1 ~

Cozy Room Tea

’m glad you enjoyed our tea and devotions visiting the fortress on the waterfront in St. Augustine. This time, I invite you to kick back and relax with a simple tea in my home. I love this cozy room that I use for creative endeavors. It used to be my youngest daughter's room. Years ago, she painted the walls a color that reminds me of chai tea. I would never have picked this color, but she is adventurous and creative. Now this room has become one of my favorite places in the house. When you walk into the room, it exudes relaxation. I have filled it with mother of pearl and cream-colored accessories, giving it the effect of a nice hot cup of tea with milk.

Pull your chair up next to my desk, and I will pour you a cup of tea from this beautiful set my husband presented me for an anniversary gift many years ago. As the steam rises, we can smell the subtle aroma of currants, citrus, and vanilla, all beautifully mixed together in a tea that delights our senses. To accompany our tea, while we chat, I am serving you some of my favorite chocolate cream puffs. The chocolate on the outside is dark and rich, and when you bite into the puff, it has the most delightful and delicate cream filling. Chocolate, tea, and cream ... what's not to love?

While we sip our tea, I'll pull a few of my favorite things out of the drawer to show you. This pen is very special to me. It was handmade for me by my son-in-law. He made it with a rich burgundy color, inserted a ring of gold dots, and surrounded it with hand-turned rings of mother of pearl and gold bands. I quite often use it to write in my journals, and those journals are where I glean stories for my devotions. Also in my drawer are some of my older journals. Here is one from the 1980s, when my children were very young. It has always been important to me to write down things that God reveals to me. My friend, sharing your faith in this way is such a special gift you can give your family. If you haven't yet discovered the joy of writing your thoughts and sharing the ways God has revealed His love to you, I encourage you to begin.

As you sip your tea, I'm sure you've noticed the scripture plaque sitting on the desk. The scripture is Hebrews 11:1 and it begins what we all know as "the faith chapter." That chapter has challenged me, motivated me, and even equipped me to dig deeper into faith in God. When I look at this particular verse, I am also reminded of times when I have struggled to have the kind of faith I know God desires for me.

My friend, fill your cup, help yourself to another cream puff, and put your feet up. It's time for me to share another true devotional story with you. It's a bit rainy outside, so I think I'll light a candle for us to enjoy while I share my heart. Here, I have an extra Bible for you. Open it to Hebrews chapter 11, and open your heart to the Holy Spirit.

Chalk Talk
Devotion

Sitting in my high school English class in 1970, there was no way to escape the irritating sound of chalk scraping across a blackboard. I tried pulling my long, straight hair over my ears and tying it under my chin like a scarf to muffle the sound, but nothing worked. That sound was so piercing that every cell in my body shuddered.

In those days, we didn't have computers in our classrooms. Chalkboards and typewriters were the tools of the trade, and I had an English teacher who was more skilled than most at using those tools. She could make a piece of chalk shriek a most disturbing note, as she wielded it across the blackboard. She had another tool in her toolbox that was just as painful—sentence diagramming. Oh, if you could only hear the tone of my voice as I say those words.

As a teenager, I was not very fond of sentence diagramming. Just the thought of it produced the same sort of torturous pain that the dreaded squeaking chalk caused. To me, sentence diagramming seemed like a total waste of time. That grammar exercise was nothing more than a chaotic mess of tangled words, out of order, and designed for the specific purpose of torturing a student.

Due to my dread and distaste of that particular grammar skill, I was completely surprised on a recent morning when the Spirit of God seemed to lead me into diagramming a sentence I was reading in the Bible. When it appears that the Holy Spirit is prompting me to do something like this, I will quite often giggle out loud and tell the Lord what a great sense of humor He has. Obviously, the motivation for this little exercise did not come from me. I would have avoided that unpleasant process at all costs. But, sure enough, there I was, at 6:45 AM, still in my nightgown, with my Bible on my lap, mentally diagramming Hebrews 11:1: *"Faith is being sure of what we hope for and certain of what we do not see"* (NIV).

Honestly now! What rational adult in their right mind would ever voluntarily consider doing a high school grammar exercise at that hour of the morning? Knowing that God really did love me, I had to believe that if He was putting me through this unpleasant sentence diagramming exercise, it had to be for a good reason. So, through sleepy eyes, I cooperated with my heavenly Father's nudge.

I've known this verse from memory for many years, but when I broke the phrase down that morning, a thought came to mind that caught me off guard. In my spirit, I heard a gentle question: "Sherri, are you SURE? Are you CERTAIN?" Admittedly 6:45 AM is just a bit too early for philosophical and theological debates. Still, the question stuck with me, so I responded to the Holy Spirit with a question of my own: "Sure and certain of what?"

Faith is the substance of things hoped for, the evidence of things not yet seen.

–Hebrews 11:1, KJV

My faith in God is unwavering, so I am always sure and certain of Him and His love for me. It wasn't that. Still, I knew deep down in my heart that I had been relentlessly praying for something specific for years, and I was questioning why the answer was taking so long. I knew that was what the Holy Spirit's question referred to.

It was then that I glanced back down at Hebrews 11:1 and mentally continued diagramming the sentence. I saw the phrases *"being sure"* and *"certain"* as if they were highlighted. I mentally pulled those words out of the sentence and just stared at them for a while. I found myself saying over and over again, *"sure and certain," "sure and certain," "sure and certain."* These words were calling my faith into action.

The Holy Spirit of God had seen my faith struggle.

Yes, my friend, I struggle. We all do at times. After many years of praying the same prayer, I was getting weary. God knew I needed a boost to propel my faith, much like a rocket needs a second booster engine to get propelled into a higher stratosphere. Sentence diagramming was a strange way to do that, but it got my attention that morning.

As the Holy Spirit nudged me to study that sentence in the Bible more closely, He reminded me of the long-standing, heartfelt, pleading request that I had been praying, and then the voice of God said, "Sherri, have faith, faith that is certain, faith that is sure!"

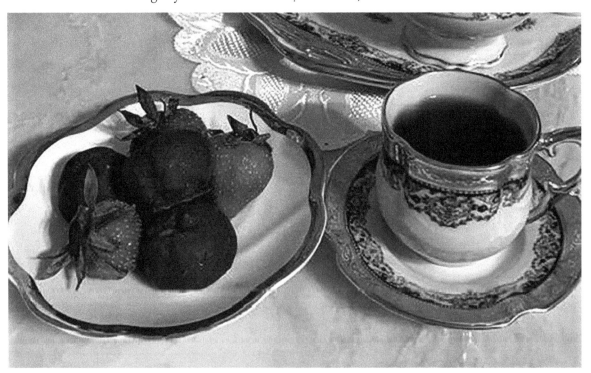

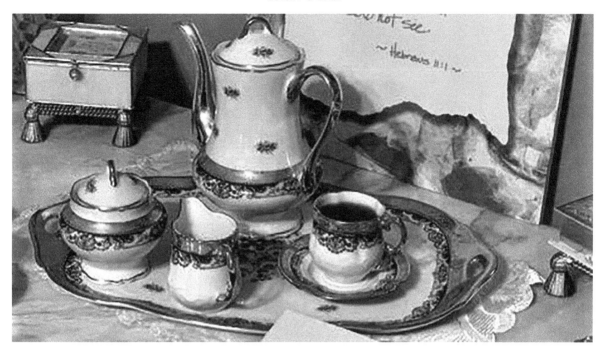

Hebrews defines faith as being absolutely certain and completely sure that God keeps His promises. Faith isn't elusive. It actually has substance. The King James Version reads: *"Faith is the substance of things hoped for, the evidence of things not seen."* Faith believes that God's Word will come to pass and produce evidence. Faith will manifest the promise.

The incredible thing is that we don't have to conjure up this kind of amazing faith that has substance and produces evidence. Jesus Himself is the *"author and perfecter of our faith"* (Hebrews 12:2, ASV). We can trust that He will create, grow, and perfect our faith in Him. He is the Author, and He will perfect it in us. *"Being confident of this, that He who began a good work in you, will carry it on to completion"* (Philippians 1:6, NIV). He will bring our faith to completion, and His Spirit will raise up in us a faith that will be sure and confident, a faith that knows with certainty that God is true to His Word. He will create in us a faith in Him that will produce evidence.

For everything that was written in the past was written to teach us, so that through endurance and the encouragement of the scriptures we might have hope.

–Romans 15:4, NIV

May the God of hope fill you with all joy and peace as you trust in Him.

– Romans 15:13, NIV

PRAYER: Oh Lord, You are a faithful and loving God. We trust in Your faithfulness, and we know that You love us enough to hear and answer our prayer. By faith, we can be confident in Your Word and sure of Your promises, even though we don't yet see them manifest. Thank You that whether I see it or not, You are already working the details to sovereignly accomplish Your will. And ultimately, Lord, we know that the purpose of our faith is not the answer we seek to our prayer. It is YOU! It is You we put our faith in. It is You whom we love. It is You we trust. Amen!

CALL TO ACTION: Read Hebrews chapters 11 and 12. Next, identify the thing that you have prayed for a long time and lost hope of ever seeing answered. Think about how much God loves you and how true His promises are. Now, rest in Him as you realize that Jesus seeded this faith inside of you, and it is He who will perfect your faith as you trust in Him to accomplish it in His perfect loving way, and in His sovereign timing.

FOR FURTHER ENCOURAGEMENT: 2 Corinthians 5:7, Matthew 14:31, 1 Peter 1:7, and Hebrews 12:2

Write here something about a time when you struggled with your faith:

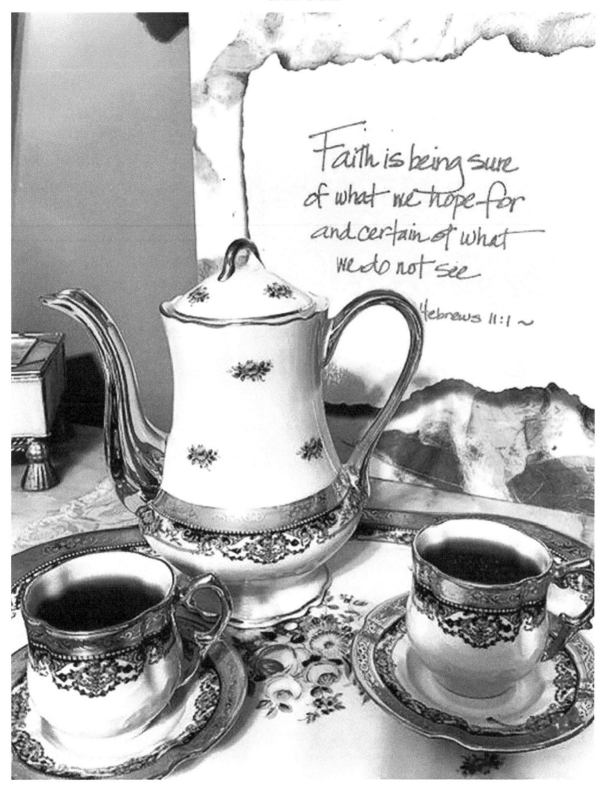

Faith is being sure of what we hope for and certain of what we do not see

Hebrews 11:1 ~

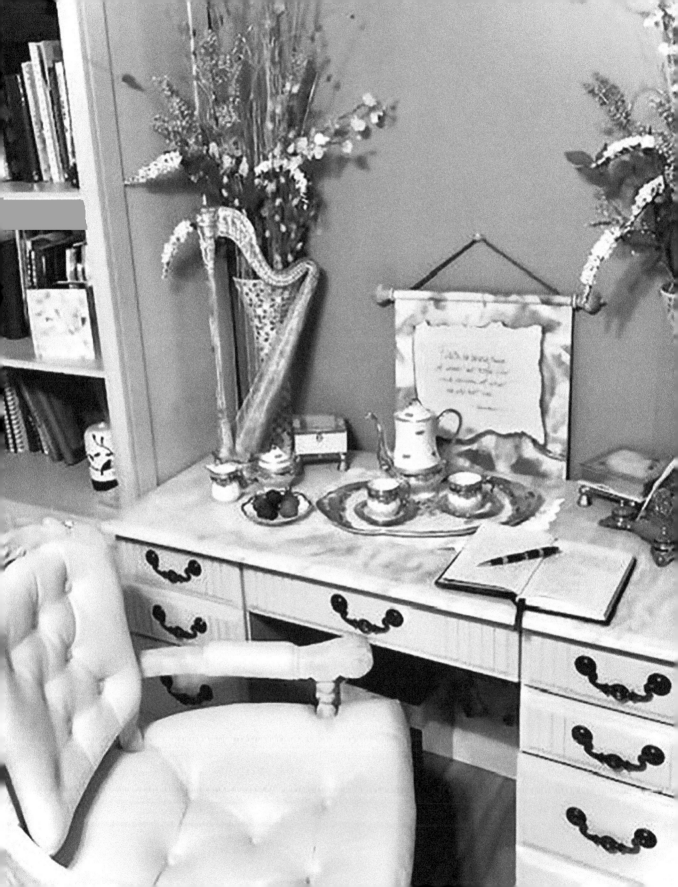

For we walk by faith, not by sight.
–2 Corinthians 5:7, NASB

We do this by keeping our eyes on Jesus,
the champion who initiates and perfects our faith.
Because of the joy awaiting him, he endured the
cross, disregarding its shame. Now he is seated
in the place of honor beside God's throne.
– Hebrews 12:2, NLT

Immediately Jesus reached out his hand and
caught him. "You of little faith," he said,
"why did you doubt?"
– Matthew 14:31, NIV

Tropical Fruit Tea

Summer lingers long where I live. Some of you may be reading this while watching the leaves change. Some of you may have this book in your hand while snow is on the ground where you live, but where I am it's still a hot, humid 90 degrees. Today tropical breezes are blowing the banana trees in my backyard, but I know we will be nearing the end of summer soon. To enjoy the last little bit of summer, I thought I would set a tropical theme tea for you to enjoy while we have our devotions.

A friend in the UK gave me this Bird of Paradise pattern tea set by Royal Stafford. It was her first wedding anniversary gift from her mother 47 years ago. What an honor and special privilege that she shared her blessing with us. Thank you, Brenda! I wish I could gather all of you around the table to meet Brenda. She is the regional director of Samaritan's Purse Operation Christmas Child in Cambridgeshire, England. She and her volunteers work tirelessly to show God's love by packing and shipping shoe boxes full of gifts for underprivileged children to countries all around the world. If you haven't had the joy of preparing a shoe box full of gifts for these children, let me encourage you to join in on the fun!

Don't you just love the bright flowers and the exotic bird of paradise motif on this beautiful bone china? Brenda's dishes are perfect for our tropical tea theme today. When I think of bird of paradise, I have to wonder if we will have birds in the "Paradise" that God has prepared for us in Heaven. As much as most of us love birds and flowers, I imagine that we might be surrounded by these lovely birds and every other wonderful, beautiful thing God has created.

Another friend has generously let us use her coral and starfish linen napkins for our tea today and provided this beautiful tropical flower centerpiece, along with some of her beautiful shells. Thank you, Cindy!

Now that the table is set, let's enjoy some tasty treats. Are you hungry yet? In keeping with our tropical theme, I am serving colorful and refreshing fruit delicacies. On the top tier of the server are berry and kiwi tarts with a custard filling on a graham-cracker crust. The bottom tier refreshes with chunks of ripe local mango, along with coconut cheesecake rounds that have coconut whipped cream on top.

Today's tea selection is Tazo orange chiffon, which is a playful mingling of Earl Grey, orange peel, and vanilla, with a splash of buttercream flavor. We will serve it in my vintage floral chintz teapot in the Summertime pattern by Royal Winton.

Our teatime has been lovely and refreshing, and it's always special having you join me. There is such a wonderful camaraderie when we gather for our teatime devotions. It's easy to share our hearts with one another when we are relaxed with a warm cup of tea in our hand.

The past few weeks have been very trying for our family as we pray and ask God for a healing miracle. I've spent a lot of time drawing near to God to seek His face. It's during such times that He reveals so much of His love and character to us. So, today, in keeping with our tropical tea theme, I want to share another true story about a tropical fruit that I love and how God used it to teach me one of His attributes.

Pour yourself another cup of tea, my friend, and have your Bible ready to look up the scriptures.

Pots of Provision
Devotion

The sweet smell of hot guavas hung thick in the air while the rhythmic sound of a metal spoon scraping the bottom of the metal pot filled my tiny kitchen. Making guava marmalade is a southern tradition passed from generation to generation in my husband's family. As a young bride, I was initiated into this "Florida Cracker" ritual by my husband's grandmother and aunt. Both of those ladies were known for transforming these exotic fruits into a tempting sweet substance for slathering on toast or fresh hot biscuits (scones for our UK friends).

My husband loves guava marmalade, not only for the taste, but for the pride of family and tradition that comes with the process. Even with both of us taking turns stirring the dark orange concoction, somehow we scorched the first batch.

Quickly we realized the culprit for this disaster was our old, thin, aluminum cooking kettle, so he decided to run out and buy a large, heavy stainless-steel one. I remained at home standing over the kitchen sink, cutting up mounds of guavas, anticipating our second attempt at marmalade making when he returned.

As I stood at the sink, draped in my white apron, cutting up the tiny yellow guavas with seedy red flesh, my husband was a few miles away, dutifully examining the various cooking pots at the store and getting distraught at the high cost. He finally selected the one he wanted and was waiting in line at the cashier when an elderly lady behind him spoke up and told him she had a pot just like he was looking at, which she never used. At her invitation, my husband put the store pot back on the shelf and followed this generous lady to her home, believing God might be leading him.

Just as she described, her pot was large, and of good-quality, heavy stainless steel, and in brand new condition. When he returned home, he triumphantly entered the kitchen with his prize. As he relayed his story to me, my spirit quickened, for I sensed that God was showing us something through this little episode.

So often we go before God, providing for ourselves, using our own resources, and trying to make things happen, when, all along, God is right there, standing beside us, waiting for us to let Him provide. Like a loving, gentle Father, I could almost hear God say. "Go ahead, use your own resources to provide for yourself, but if you will just wait, if you will only listen to My voice and wait for My timing, I will provide for you." At that moment, I remembered one of the names for God in the Old Testament is Jehovah-Jireh. In Hebrew, it means "The Lord will provide."

I was so excited about this reminder of God's provision, which He had so lovingly put in our path, that I called all our grown children and gave testimony to what God had just spoken.

The more I thought about this the more I realized what disastrous consequences can sometimes result when we jump ahead of God's provision and His timing. We read in Genesis 17-21 that Abraham knew of God's promise to provide. God had promised Abraham a son in his old age, but he and Sarah got tired of waiting, ran ahead of God, and tried to make the promise happen themselves, instead of waiting on God. The result was hurt and conflict. Entire nations and all of history have suffered the consequences as we can see in the ongoing Middle-East conflict.

Maybe a stainless-steel pot has no historical impact or spiritual significance. Still, God used it to remind me that if we heed His voice and wait on His timing and His provision, we will have what we need. He does the same for all of us.

This doesn't just apply to material possessions or financial provision. God provides everything we need for life, and He has given us so many promises to remind us of this. Look at just a few of the scripture promises of God's provision. Are you single and need God to provide a spouse? *"But my God shall provide all your need according to his riches in glory in Christ Jesus"* (Philippians 4:19, KJV). Are you weak and need God to provide strength? *"Those who hope in the Lord will renew their strength. They will soar on wings like eagles, they will run and not grow weary, they will walk and not faint"* (Isaiah 40:31, NIV). Do you need God to provide direction? *"For I know the plans I have for you declares the Lord, plans to prosper you and not to harm you, plans to give you a hope and a future."* (Jeremiah 29:11, NIV). Do you need peace in your heart during these difficult times? *"The peace of God which transcends all understanding will guard your heart and your mind in Christ Jesus"* (Philippians 4:6-7, NIV) Perhaps you need God to provide healing for your body? *"Praise the Lord oh my soul and forget not all His benefits, who forgives all your sins and heals all your diseases"* (Psalm 103:2-4, NKJV). *"By His stripes we are healed"* (1 Peter 2:24, NIV).

But my God shall supply all your need according to his riches in glory by Christ Jesus.
– Philippians 4:19, KJV

Bless the Lord, O my soul, and forget not all His benefits.
– Psalm 103:2, NKJV

There is absolutely nothing we could need, that God in His great love and mercy hasn't provided for us. When we seek Him and wait on His voice, we can enjoy knowing God is our Provider, and through our trust in Him we will bring glory to His name and His Kingdom.

As I spread the warm and perfectly cooked guava marmalade on my toast, I pray, "Oh, God, you indeed are our Provider. Enable us to sense You standing near. Enable us to hear Your voice and empower us by Your Holy Spirit to wait patiently on You. Forgive us for the times we have run ahead of You and relied on ourselves. Give us eyes to see and ears to hear as Your Spirit directs us and provides for us. Amen!"

And God is able to make all grace abound toward you, that you, always having all sufficiency in all things, may have an abundance for every good work.
—2 Corinthians 9:8, NKJV

PRAYER: Lord, we all have such a tendency to try to make things happen for ourselves. Forgive us when we run ahead of You and get in the way of Your plans and Your timing. We know that You are a loving provider and will meet all our needs in a way that will bring glory to You and not to us. Help us to see Your hand at work and not to be anxious when we can't see the end result right away. Enable us to fully know You in all Your ways. Amen!

CALL TO ACTION: Be honest with yourself this week and try to become aware of all the little ways that you tend to take charge and try to make things happen when you are tired of waiting on God. Repent of putting your plans in the forefront and ask God to give you insight into all the many ways He is working on your behalf.

FOR FURTHER ENCOURAGEMENT: Proverbs 3:5

Write here about a time when God provided something for your family:

Be anxious for nothing, but in everything by prayer and
supplication, with thanksgiving, let your requests be made
known to God; and the peace of God, which surpasses all
understanding, will guard your hearts and minds
through Christ Jesus.
– Philippians 4:6-7, NKJV

Trust in the Lord with all your heart
and lean not on your own understanding;
in all your ways submit to him,
and he will make your paths straight.
– Proverbs 3:5-6, NIV

But those who hope in the Lord
will renew their strength.
They will soar on wings like eagles;
they will run and not grow weary,
they will walk and not be faint.
–Isaiah 40:31, NIV

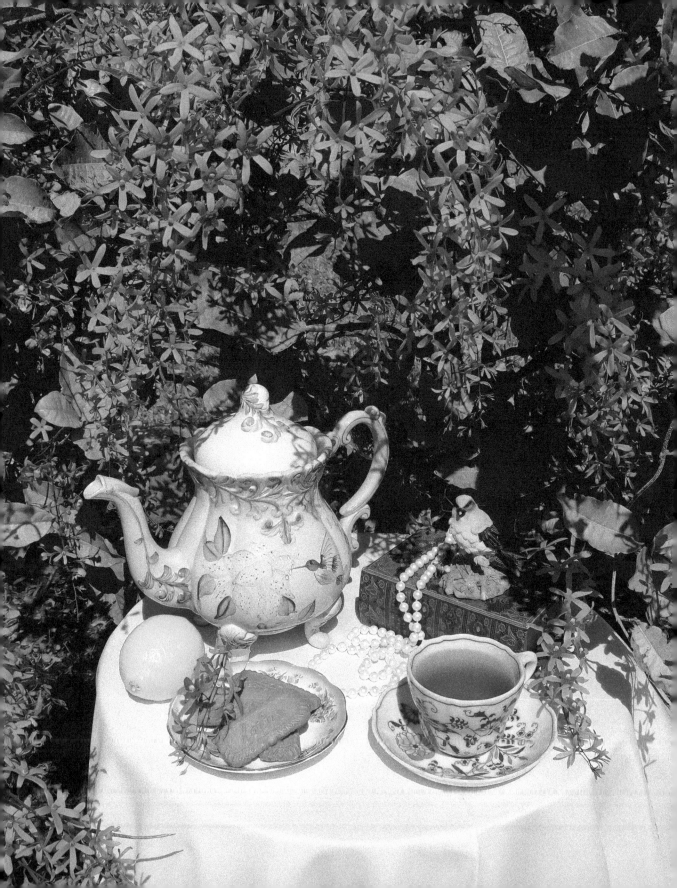

Tea Under the Queen's Wreath

Today the wind is beckoning us to enjoy a lovely afternoon tea outside. As we carry our tea things out, I'm reciting an L.M. Montgomery quote: "March came in like the meekest and mildest of lambs, bringing days that were crisp and golden and tingling." My friends, your heart will soar on this crisp, golden, tingling March day, because we are having tea under my favorite purple flowering bush, called Queen's Wreath. The effect of this bush in bloom is similar to wisteria in its cascading effect. When the sun shines through the petals, they take on a lovely lavender hue. I love to get very close and watch the bees dance inside the tiny purple blossoms. It doesn't bloom this luxuriously very often, so let's capture the moment and savor the day with an alfresco tea.

You carry this soft buttercream tablecloth, and I'll carry this large teapot filled with the aromatic Harney & Sons of Paris tea. The grass is warm beneath our feet as we walk toward the bush. On such a warm and beautiful day, all we need is a few ginger cookies to enjoy with our tea.

This vintage teapot is unmarked, so I don't know its origins, but it is so lovely with the hummingbird and flower painting and looks like it belongs with the Queen's Wreath. Our teacup is the very popular Blue Danube pattern, popular in the 1960s and given to me by an aunt.

As we spread our tablecloth and set up our tea, a cardinal is singing in the mango tree nearby, and a blue jay is curiously watching us from a nearby hedge. The wind is making the purple flowers dance for us while we sip our tea. Ahh, what a tranquil morning! It's the kind of moment we want to savor.

I'm so glad you're having tea with me today, and I know you want to linger near these beautiful flowers, so relax and have a cookie. While you enjoy your tea, let me tell you about a cold winter morning that wasn't quite so tranquil as today.

Pecky Cypress Crisis
Devotion

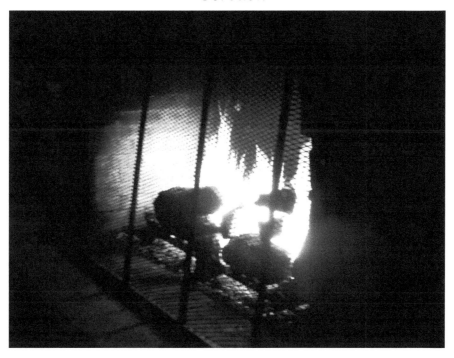

Snuggled into the corner of my big brown sofa, with extra pillows propped all around me and my favorite blanket draped over my lap, I was ready for a morning of relaxation. A fire crackled in the fireplace, and my hot tea waited on the coffee table in front of me. I was ready to relish a few quiet moments of reading my Bible and having morning devotions, while my husband slept in the next room.

Living in South Florida, we have only a few days a year that we can enjoy our fireplace. In the 40 years I have lived in our home, the fireplace hasn't seen much use, so a day that is cold enough to light some wood and enjoy a cozy fire is relished like a favorite cake. Our fireplace is massive and made of large, white, hand-cut Georgia pecan stones that go all the way to the ceiling. It is flanked on both sides by beautiful tongue and groove pecky cypress

planks. That stone fireplace and the rare pecky cypress wall are the favorite features of our home.

After reading a few chapters in my Bible, I glanced up for a moment to enjoy watching the flames dance in the firebox. Suddenly, I noticed something that took my breath away and caused immediate alarm to rise in my soul. Something was very wrong. There was a small puff of smoke coming from one of the knot holes in the pecky cypress wood on the right side of the fireplace. Thankfully, my husband was home, so I ran to the bedroom to awaken him as gently as I could, to tell him our beautiful wall was smoking like a peace pipe. Still half asleep and not fully comprehending, he muttered that everything was all right and not to worry about it. What? How could he say that? Smoke is supposed to go up the chimney, not come out of the knot holes in our beautiful wood wall.

After several attempts to awaken my husband, he finally aroused enough to come to the living room to look, still not fully comprehending what was happening … until he saw it for himself. Being an electrician, the first thing he did was check to be sure there wasn't an electrical short in the outlet on that wall. But, no, the small trail of smoke was definitely coming from the holes in the wood, not from the outlet. Quickly he doused the flaming logs and carried them outside, then thoroughly cleaned out the firebox. We discovered that there was a very tiny crack in the wall of the firebox, allowing a small amount of smoke to flow through the bricks, go behind the fireplace, and seep out the holes of our beautiful wood wall. My perfect morning had taken a sudden turn.

Examine yourselves as to whether you are in the faith. Test yourselves. Do you not know yourselves, that Jesus Christ is in you?–unless indeed you are disqualified.
.– 2 Corinthians 13:5, NKJV

A few hours later I began pondering what had happened. How had we allowed this damage to go unnoticed? Why hadn't we examined the mortar on a regular basis? Like most events that happen in our lives, if we ask the Holy Spirit, He will give wisdom and revelation, especially if there's something He wants to show us. I began to realize how easy it is for us to go about our daily routines year after year and not notice when the enemy of our souls is trying to create a crack in the mortar of our lives. We can get so busy with home, children, jobs, even church activities and ministries that we fail to slow down and take time for regular self-examination.

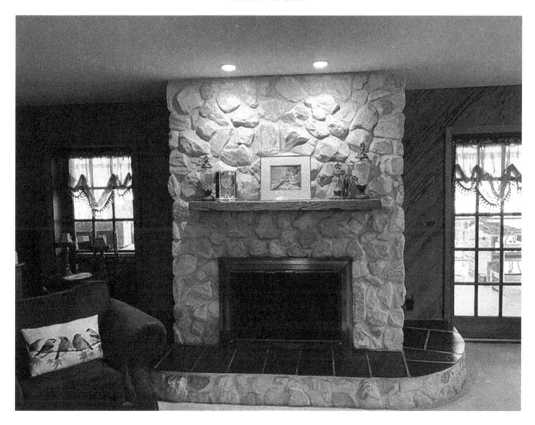

Search me, O God, and know my heart! Try me and know my thoughts!

– Psalm 139:23, ESV

In 2 Corinthians 13:5 (NLT) Paul was urging the church at Corinth to *"examine yourselves."* He was letting the Christians in that church know that the enemy could slip in without them being aware of it and damage relationships between them and their God ... unless they routinely examined themselves.

Sticking my head in the firebox to examine the chimney isn't the most pleasant job and requires washing the soot off my face when the task is complete. Self-examination isn't always pretty either, but the Bible gives us the perfect prayer to guide us through the self-examination process: *"Create in me a clean heart, O God; and renew a right spirit within me"* (Psalm 51:10, KJV). I'm a firm believer that we should whisper that prayer every morning as faithfully as we brush our teeth. If our hearts speak those words prayerfully and honestly on a daily basis, God will do the cleansing work in us.

As I aired the house from the smell of smoke, I realized that all of us need to routinely reflect on our actions, motivations, and thoughts. We need to be sure that the "mortar" holding our lives together is grounded in Christ and His holy Word. We all need to inspect daily for any cracks in our mind, will, or emotions that would give place for the enemy to wreak havoc in our souls. While the Holy Spirit is guiding us through this self-examination, we can rest in the knowledge that our Savior, the Lord Jesus Christ, has paid the price for our salvation and sanctification, and He alone has paved the way to victory. We need not worry, because the blood of Jesus is the mortar that holds us safe and secure. We can rest in His all-encompassing love and keeping power.

Create in me a clean heart, O God,
and renew a right spirit within me.
– Psalm 51:10, ESV

PRAYER: Heavenly Father, thank You for sparing my home from damage, but more than that, thank You for loving all of us enough to send Jesus to rescue us from the destruction the enemy tries to accomplish in our lives. Thank You for Your loving faithfulness in our lives every single day.

CALL TO ACTION: Be aware of the times the Holy Spirit is drawing you to examine yourself, and don't shy away from His loving inspection. He will reveal where His love and His blood can heal any cracks and restore you to wholeness.

FOR FURTHER ENCOURAGEMENT: John 10:10, James 1:23 and 25, and 1 Corinthians 13:5.

Write here here about a time when you allowed God to search your heart:

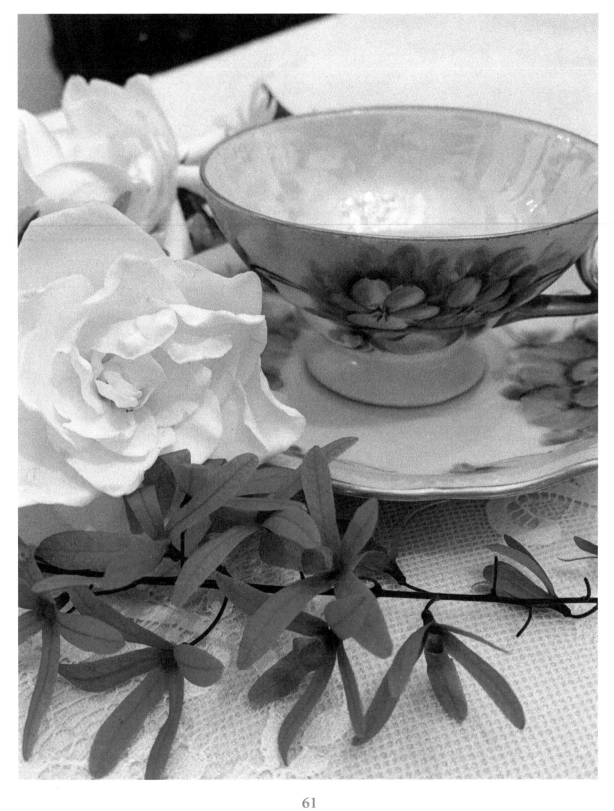

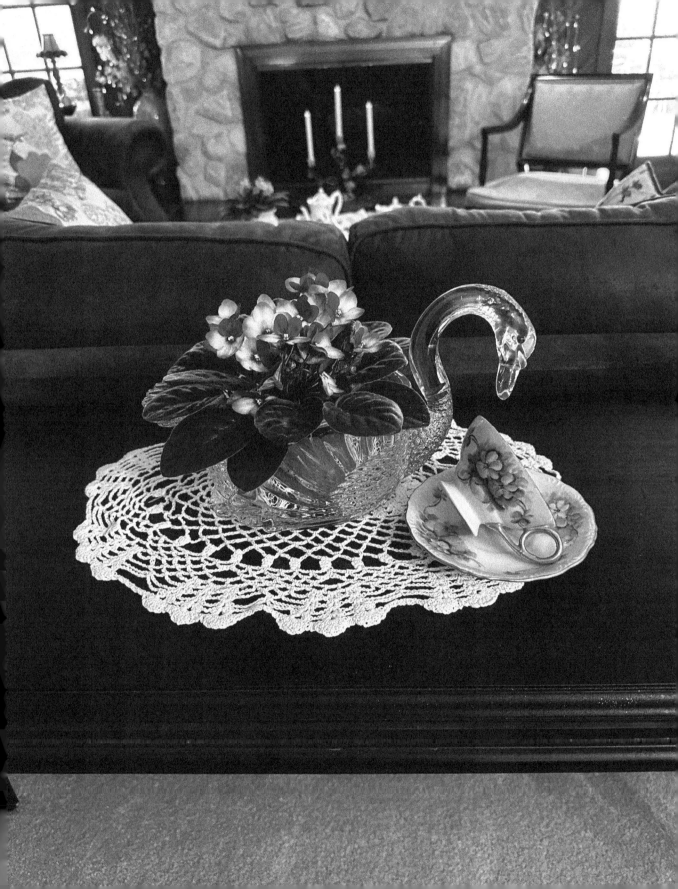

The thief does not come except to steal,
and to kill, and to destroy.
I have come that they may have life,
and that they may have it more abundantly.
– John 10:10, NKJV

Anyone who listens to the word but does not do what
it says is like someone who looks at his face in a mirror.
– James 1:23, NIV

But whoever looks intently into the perfect
law that gives freedom, and continues in it—
not forgetting what they have heard, but doing it—
they will be blessed in what they do.
—James 1:25, NIV

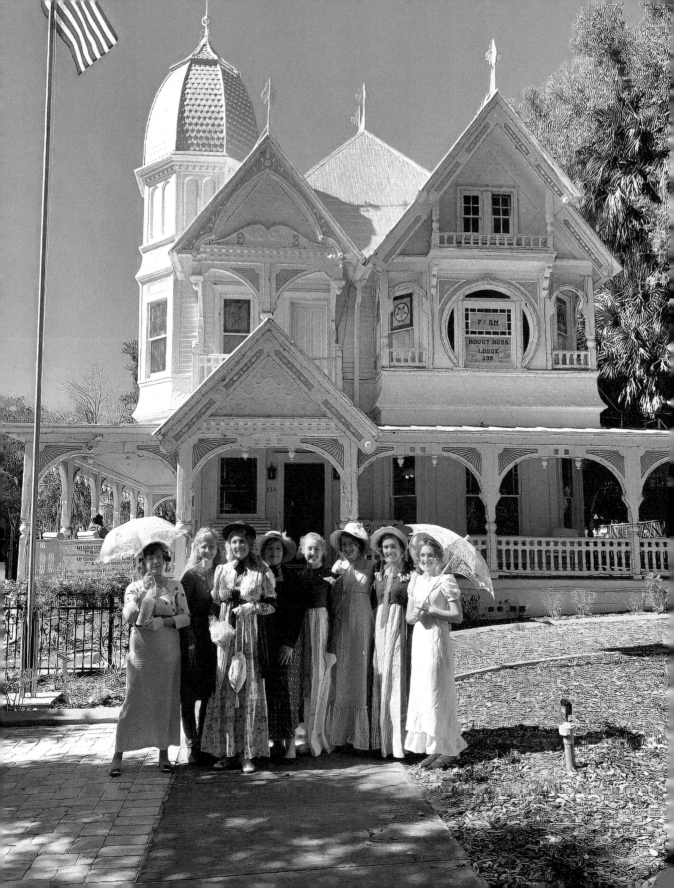

Tea at Mount Dora

oday you are invited to take a moment to let your mind have a break from stress and mentally escape for a few moments to restore your soul. I invite you to join me for a four-course afternoon tea at the annual Jane Austen Regency Festival in Mount Dora, Florida. If you love *Pride and Prejudice, Emma,* and all things Jane Austen, you are going to love today's teatime. So, put your strolling shoes on and, as Elizabeth Bennet would say, "Take a turn with me."

For many weeks, in anticipation of this event, my daughter-in-law, granddaughters, and a good friend sewed Regency Era dresses, handmade and lined authentic Spencer jackets, crafted bonnets, embroidered handbags, and practiced Regency Era hair styles.

Mount Dora drips with the charm of small-town America. Everywhere we look, we see moss-draped oaks, flowering magnolias, and American flags flying in the wind on whitewashed front porches. Small antique shops line the streets dispersed between lovely cafés. As we stroll along the sidewalk with our parasols shading us from the sun, we approach a majestic Queen Anne style home built in 1893. This is the historic Donnelly House which is listed in the U.S. National Register of Historic Places. We are excited to learn that this is where our tea will be served today.

There is such anticipation as lace-aproned hostesses usher us into the antique bedecked parlor. As soon as we see the table settings fit for a queen, we know we are in for a lovely experience. Seated at a big round table by the window, we enjoy the ambiance and notice the variety of patterns on our china teacups. Small vanilla scones with clotted cream and lemon curd start us on this delicious adventure.

The center of the table has a three-tier server bedecked with delights. Shrimp vol-au-vent, cucumber sandwiches, and chicken salad on croissants grace the bottom tier. The middle tier delights us with the promise of chocolate cream cheese squares, lemon pound cake, and dainty cookies. The top tier is mounded with beautiful flowers putting a smile on all our faces. I'm so glad you are enjoying this along with us.

While our server pours the house specialty tea from a lovely pink Brown Betty teapot, I begin to pass out the gifts I have prepared, and everyone enjoys reading the Jane Austen quotes I put on their cards. My favorite is: "It isn't what we say or think that defines us, but what we do" (*Sense and Sensibility*).

Soon two Regency-costumed ladies approach our table and begin an entertaining dramatic reading from *Emma*. Sipping our tea, called "Divine Jane," we are transported to a different time and place.

Tea time was delightful, and now it's time to make our way down to the waterside to the ballroom for a soiree'. Along the way the girls enjoy peeking in the windows of charming buildings. Once we are inside the ballroom, the music lures us to the dance floor, and we all enjoy learning English Country dances. Holding out our skirts, we swish and swirl around the room and imagine living in a bygone era. Those dances from the past were all about fast steps and quick changes. It reminds me of a story I want to tell for today's devotional thought.

So, sit back, relax with your tea, and let me share with you how this precious moment with my family helped me see a wonderful attribute of God's love for us all.

Daddy's Shuffle Step
Devotion

The sound of laughing and giggling, combined with the sound of quick footsteps were heard as both of my daughters and my husband walked in front of me, arm in arm, stepping in unison with each other. I loved observing them together. They would get a good rhythm going, while calling out "Left! Right! Left! Right!" They were laughing and stepping in perfect synchronization as if they all had only one set of feet. It has always put a smile on my face to watch the delight of both father and children walking in complete unison and loving the process.

My children would laugh as much with the joy of being in step with their dad as they did in anticipation of knowing that, at any moment, he would do a fast shuffle and quickly shift his feet so that the opposite foot was first. It always delighted them to show him how fast they could match his step, to once again be in unison with him. It is a game they still play, even today as grown adults whenever they are walking beside their dad.

Anytime I read Galatians 5:25, *"... let us also keep in step with the Spirit"* (ESV), the memory of my husband and my daughters walking in step with one another comes to mind. So I have to pause and wonder, and perhaps you do as well: exactly how do we "keep in step" with the unseen Spirit of God?

Picturing my daughters keeping in step with their daddy makes me realize that it took both sight and hearing, combined with a close relationship, for them to walk in step with each other. The children trying to keep in step with their father requires closeness, and it requires them to "see" their daddy. Their ability to follow his shifting steps would be difficult, if not impossible, if they couldn't see him. They have to stay close enough to him to see his changes, and they have to be willing to change their direction ... if they want to keep in step with him.

It's the same in our daily walk with God. If we want to live out what Galatians 5:25 (ESV) says, *"... keep in step with the Spirit,"* we need to first be in close communion and relationship with our Lord Jesus Christ. We need to ask Him to give us eyes to see when He is shifting directions, so that we can joyfully shift our direction to keep in step with Him. We also need to have ears tuned to the heartbeat of God so that we can "hear" His voice leading us.

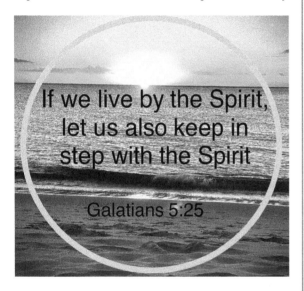

If we live by the Spirit, let us also keep in step with the Spirit

Galatians 5:25

Since we are living by the Spirit, let us follow the Spirit's leading in every part of our lives. – Galatians 5:25, NLT

Have you ever wondered why a marching band frequently has the drummer positioned out front? If they are to have uniformity, they need to "hear" the beat. The sound of the beat determines the rhythm of their steps and keeps them marching in unity. Our spiritual ears need to be tuned to the heartbeat of God so that we can shift directions when He does. When walking in close communion with our Lord, we find that it can be a joy and a delight to shuffle our current direction to stay in unison with Him. When God "shifts" us in a new direction, instead of being unsettled, we can giggle with delight at the change, even as my children do when walking in step with their earthly father.

The past few years, a new virus caused a quick change in most of our daily routines. We may have been giggling with delight at the direction God was taking us yesterday, but today there seems to be a sudden need for a quick shuffle. Most of us suddenly feel restless and "out of step" with the new rhythm of our changing world. How do we, as God's people, respond when a sudden change like this takes place in our lives? Jesus encouraged us in Matthew 18:3 (KJV): *"... become as little children"* Perhaps the way my daughters responded with their daddy when he made a change is how we need to respond to a world crisis. Perhaps the Lord is telling us to draw closer to Him and to listen more intently. Perhaps He wants us to take delight in being close enough to Him to notice when He is telling us to shift.

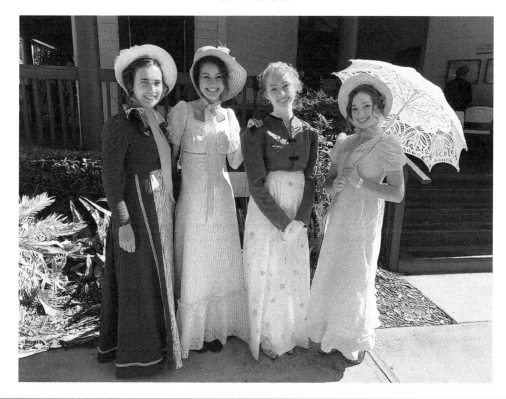

For as many as are led

by the Spirit of God,

they are the sons of God.

–Romans 8:14, KJV

Our God is the Creator, and He has placed in each of us many creative gifts and abilities. These shifting times are an opportunity to find creative ways to minister to one another and to be witnesses to those who don't know our Lord.

The world is watching! Will we panic at the change or take delight in shifting our steps, to walk in total unison with our Savior and find ways to share His love and the light of His Gospel with others? Maybe He is asking us to be more aware of everyone around us and not be so absorbed in the direction of our own steps. Yes, it requires a quick shuffle, but led by His Spirit, we can honestly pray, "Lord, enable my eyes to see You and my ears to hear You, and show me how to embrace the process when You shuffle Your step."

So You led Your people [O Lord]
To make for Yourself a beautiful and glorious name [preparing the way for the acknowledgment of Your name by all nations]..
– Isaiah 63:14, AMP

PRAYER: Heavenly Father, it is such a privilege to walk through life with You. Thank You that You help us hear Your voice and know Your ways. Enable me to creatively minister to those who are lonely and isolated for any reason. Lord, enable me to take delight in You, as Your direction for all of us changes. Enable us to trust and not to fear. Amen!

CALL TO ACTION: The next time you are walking beside someone you love, try this little shuffle-step exercise. Then, as you have fun keeping in step with one another, allow joy to fill your heart as you dwell on your walk with your heavenly Father.

FOR FURTHER ENCOURAGEMENT: Proverbs 3:5-6, Psalm 119:105, and Colossians 2:6.

Write here about how God has guided your steps:

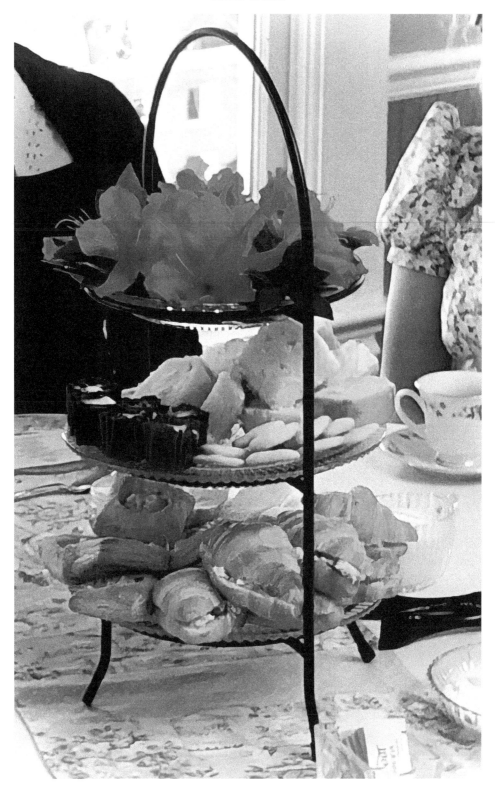

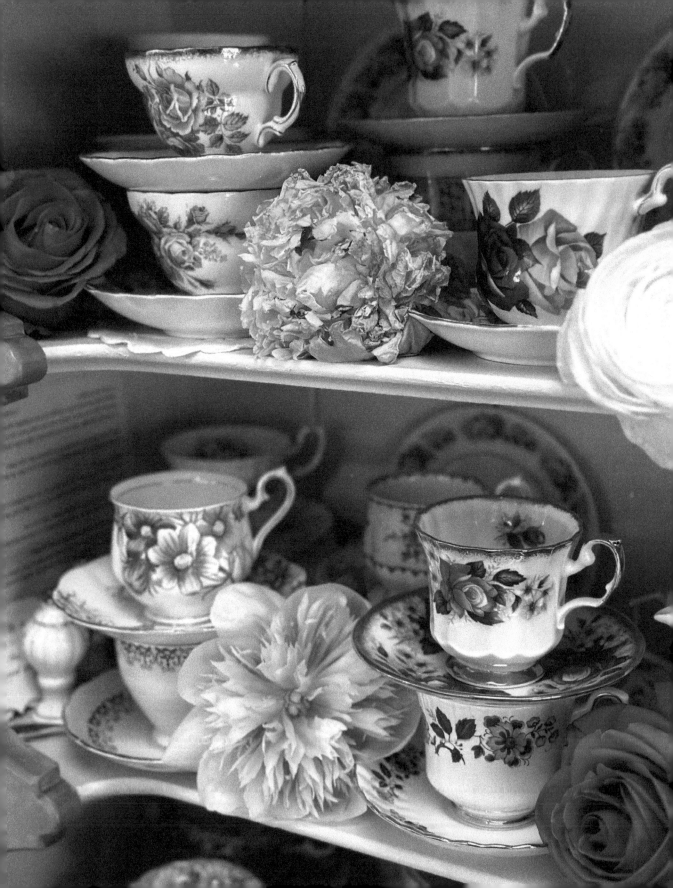

Your word is a lamp to my feet
And a light to my path.
– Psalm 119:105, NKJV

So then, just as you received Christ Jesus as Lord, continue to live your lives in him, rooted and built up in him, strengthened in the faith as you were taught, and overflowing with thankfulness.
– Colossians 2:6-7, NIV

So that with one accord you may with one voice glorify and praise and honor the God and Father of our Lord Jesus Christ.
– Romans 15:6, AMP

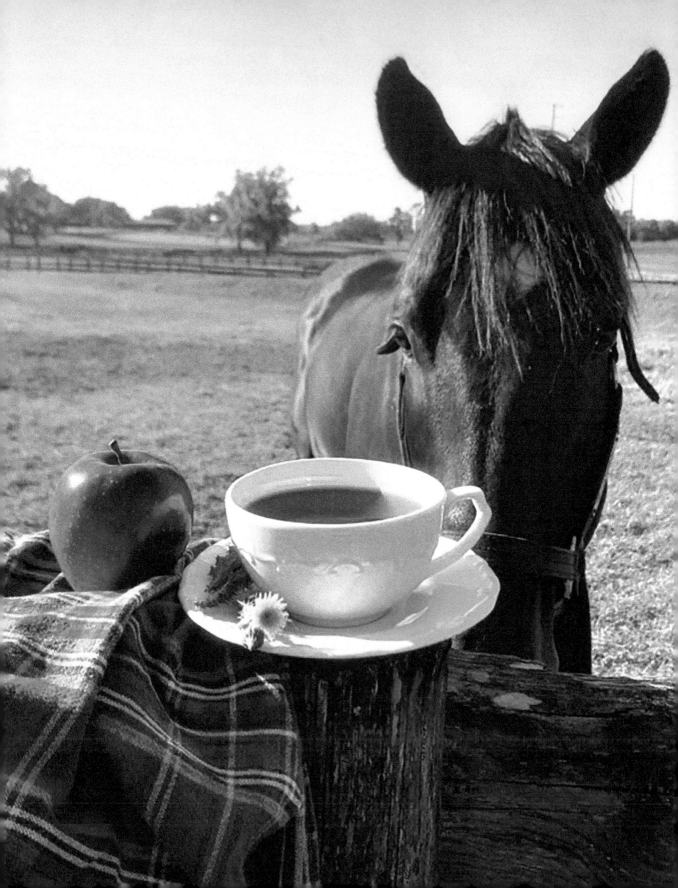

Tea with a Race Horse

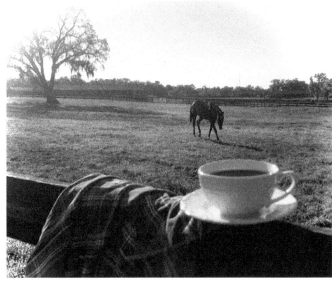

Are you ready to put on some comfy clothes and go somewhere to stretch out and breathe in a peaceful moment? I invite you to take a trip with me to the countryside. In this restless age, I think we can all use a time of rest and relaxation to enjoy fresh air and sunshine, don't you?

Tea time doesn't always have to be fancy, so today, let's just pack a comfy homemade quilt and a simple white porcelain teacup and carry a thermos of Earl Grey tea. I'm going to take you to a 700-acre farm in race horse country in Ocala, Florida. Come on, kick off your shoes, let's spread out a home-made quilt, let the warm sun relax us, and watch the breeze blowing the tall field grasses. In this quiet place we can have a heart-to-heart chat together over tea, and remind each other that God is still on His throne.

You can stretch out on this quilt and relax, or you can join me as I walk through the field of grasses and dandelions, to pick wild flowers. Although I usually love an elegant teatime, I'm a bit of a flower child at heart, and ... shhh ... I'll let you in on a secret: there's a little bit of country in me too.

This field is full of all manner of grasses and wild flowers. As I pick a handful of dandelions to put in my hair and decorate our teatime, I'm reminding myself to try making dandelion tea someday.

We are in the middle of the farm, and as we sip our tea, we can watch the trainers on the other side of the fence putting their horses through the paces around the track. Every horse that comes around the corner is so different. There is a beautiful horse grazing not too far from us, so why don't we invite him to join us for tea!

He must have heard us because, as I balance my teacup on the railing, he immediately trots over for a closer look. I'm sure the bright, shiny red apple we offered him has piqued his curiosity. He stands there eyeing our teacup for a few moments, and as we speak with soft gentle voices, we can tell he is listening. You can almost see the trust developing. He knows we are talking to him, and I think he even knows we are inviting him to join us for tea. And, soon enough, he does just that!

We have enjoyed our walk and had fun with this handsome fellow, so let's take our teacup back to the quilt and relax while I share today's devotion.

Watching these horses respond so quickly to the voice of their trainers reminds me of a time when God showed me how important it is for us to know His voice, and respond without hesitation.

Stretch out, take a sip of tea, and I'll tell you the story.

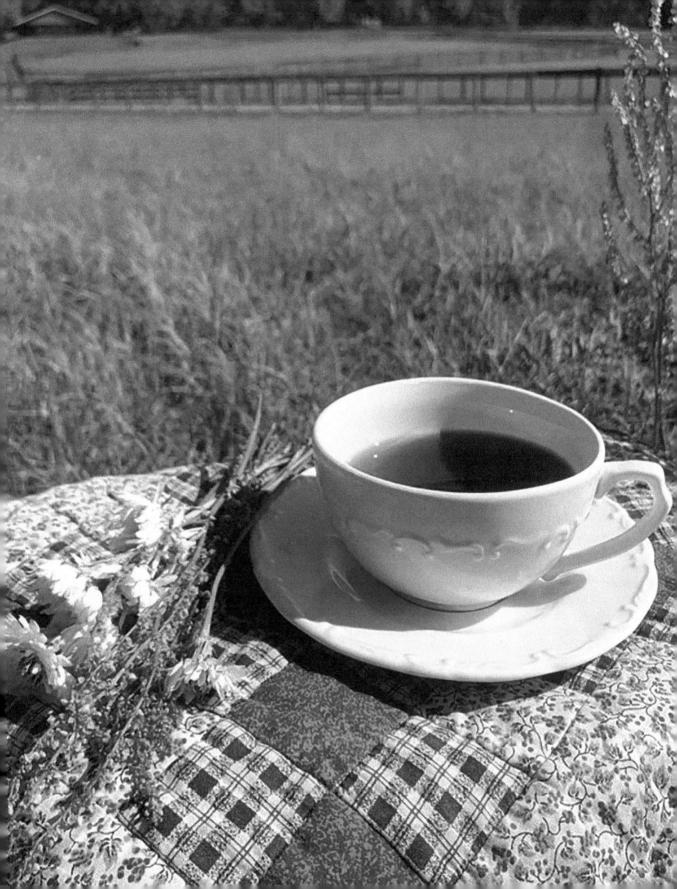

When He Speaks, Listen!
Devotion

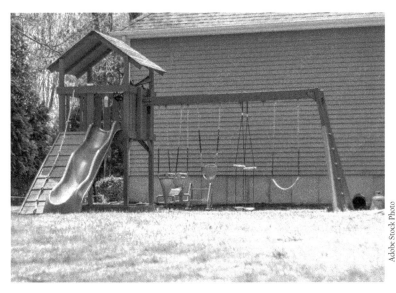

Adobe Stock Photo

Today if you hear His voice, Do not harden your hearts
– Hebrews 3:7-8, NIV

The year was 1980 and I was a young mother with a 5-year-old son and 2-year-old daughter. From the moment our first child was born my heart longed to be a stay at home mother. We needed a second income while my husband built a new business, so, like many young families I juggled career and parenting, working full time as an EEG technician at the local hospital. Every day my shift ended at 3:00 PM, and every moment of that shift was torture, for I longed to be with my babies. As soon as the clock struck 3:00, I drove straight to the daycare to pick them up.

We had recently built a new home on an acre of land in an undeveloped neighborhood, and we loved watching our children play in the big, roomy backyard on their swing set. Every day, when I got home with my children, the routine was the same. I would always open the sliding glass door and give them a few minutes to play on the swing set outside while I quickly changed out of my uniform, then joined them for a few moments of fresh air and sunshine. I was a woman of routine, and that routine never fluctuated ... not until that day!

On this particular day, I felt the need for a minute to myself after work before picking up my children from daycare. My children are everything to me, so this was very out of character, but instead of driving to pick them up, I went home for a few minutes before going to the daycare center. Instead of resting or using the time for prayer or Bible reading, I found myself getting busy.

Your ears will hear a word behind you, saying, "This is the way, walk in it," whenever you turn to the right or to the left.

–Isaiah 30:21, NASB

There was a load of laundry in the washer that needed hung on the line, so I filled the basket with the wet laundry and walked through the living room toward the sliding glass door that led outside where the children's swing set and my clothesline were. The basket was mounded so high that I couldn't see very well over it. As I fumbled to open the slider with this big basket in my arms, a thought interrupted me. This thought was loud, distinct, and precise. It felt like the Lord was talking to me and in my spirit, I heard "Sherri, you're ignoring me!" That stopped me right in my tracks. I love my Lord and Savior, and I surely didn't want to ignore Him. I didn't open the sliding door to go out. Instead, I immediately stepped backward and plopped down on the sofa, put down the laundry, and picked up my Bible to have devotions. I had learned a long time before how important obedience to the voice of the Lord is, and that day, it was a good thing I did!

Adobe Stock Photo

As I picked up my Bible, I glanced over at the sliding glass door, and right at the threshold, on the other side of the glass, coiled, and poised for a strike, was a 6-foot diamondback rattlesnake. There is no way to describe the terror! I remember shaking with fear as the "what ifs" took over my thoughts. What if I had ignored God's voice and walked out that door? Worse yet, what if I had ignored the urge to leave my children at the daycare a little longer that day? What if I had followed my set routine and sent them outside to play at that moment?

I called my husband to come home but just as he arrived, the snake was slithering off the patio. We quickly hired a company to clear the back of our lot. I remember seeing the driver hop off his tractor and run up to our house to tell us that as they were bulldozing, they discovered and destroyed a large snake pit containing five large rattlers. As the reality of the story sunk in, tears of gratitude to the Holy Spirit began flowing, and my heart swelled with praises for God's lovingkindness to warn me and protect my family.

Over the years since that event, I have often thought about the voice of the Lord and pondered on the many ways He talks to us. I think about Moses hearing the voice of God from the burning bush. The story of Samuel actually hearing God audibly speak to him and call his name has always intrigued me. Wouldn't it be wonderful to actually hear the audible voice of the Lord?

Most of the time we don't "hear" an audible voice from the Lord, but He still speaks to us clearly and distinctly through His Word. Romans 10:17 (KJV) says *"Faith cometh by hearing, and hearing by the word of God."* We can "hear" God speak to us as we read the Bible.

God also speaks to us by directing our steps. Psalm 37:23 says that our steps are ordered and directed by the Lord. He surely directed my steps that day! Even as I know without a shadow of doubt that God directed my steps that day, I am painfully aware that I could have turned a deaf ear and continued going my own way. If I hadn't immediately responded to God's voice, we could have had a very different outcome to the story. We are warned in Hebrews 3:7-8 (NIV) *"Today, if you hear his voice, do not harden your hearts"* The Bible makes it clear that God's children can recognize His voice, but He also wants us to have hearts, not only to hear, but also to obey.

"... the sheep hear his voice; and he calls his own sheep by name and leads them... he goes before them; and the sheep follow him for they know his voice" (John 10:3-4, NASB).

"Your ears shall hear a word behind you, saying, 'This is the way, walk in it,' when you turn to the right or when you turn to the left" (Isaiah 30:21, ESV).

I will admit that I don't hear the voice of the Lord all the time. Thankfully, I heard and responded that day, but I know there have been many other times that I either failed to hear His voice or stubbornly continued about my busyness and didn't stop to respond or obey. None of us are perfect. We often miss the mark, but thanks be to God, we haven't been left in this condition.

I am so grateful to Jesus for sending the Holy Spirit to indwell us. Listen to His prayer: *"And I will ask the Father, and He will give you another Helper, to be with you forever, even the Spirit of truth....you know Him for He dwells with you and will be in you"* (John 14:16-17, ESV).

My friends, God is not distant or silent. He is Immanuel, God with us! He is constantly with us and constantly speaking to us every moment of every day. All we have to do is tune our ears to Him and listen.

My sheep listen to My voice, and I know them, and they follow Me;

— John 10:27, NASB

79

I give them eternal life, and they will never perish;
and no one will snatch them out of My hand.
– John 10:28, ESV

PRAYER: Heavenly Father, what a comfort it is to know that You love us so much You desire to speak to us every day. What a privilege it is that You gave us Your Word, the Bible, to guide us, and that You give us Your Holy Spirit to speak to us. Lord Jesus, enable me to slow down enough to hear when You speak to me. Please show me how to listen and recognize Your voice among all the voices of the world clamoring for my attention. Thank You for Your all-encompassing, all enabling love. Amen!

CALL TO ACTION: Try to be aware of when your routine keeps you so busy you don't slow down to listen to the voice of God. Try to make purposeful moments to sit quietly and ask God to help you recognize His voice. If you don't know His voice, read your Bible, get to know Him, and remember that you are hearing Him speak to you through every word you read. The Bible is God's love letter to you.

FOR FURTHER ENCOURAGEMENT: Jeremiah 33:3, John 10:27-28, Hebrews 4:12, and 2 Timothy 3:16.

Write here about a time you failed to listen to God's voice:

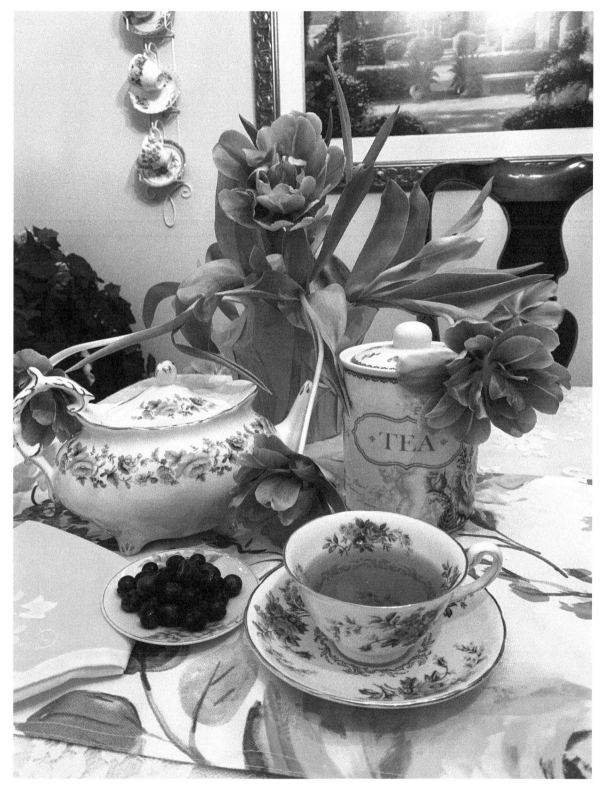

And I will ask the Father, and he will give you
another advocate to help you and be with you forever—
the Spirit of truth. The world cannot accept him,
because it neither sees him nor knows him. But you
know him, for he lives with you and will be in you.
– John 14:16-17, NIV

For the word of God is alive and powerful. It
is sharper than the sharpest two-edged sword, cutting
between soul and spirit, between joint and marrow.
It exposes our innermost thoughts and desires.
–Hebrews 4:12, NLT

The gatekeeper opens the gate for him, and the sheep listen to
his voice. He calls his own sheep by name and leads them
out. When he has brought out all his own, he goes on ahead
of them, and his sheep follow him because they know his voice.
–John 10:3-4, NIV

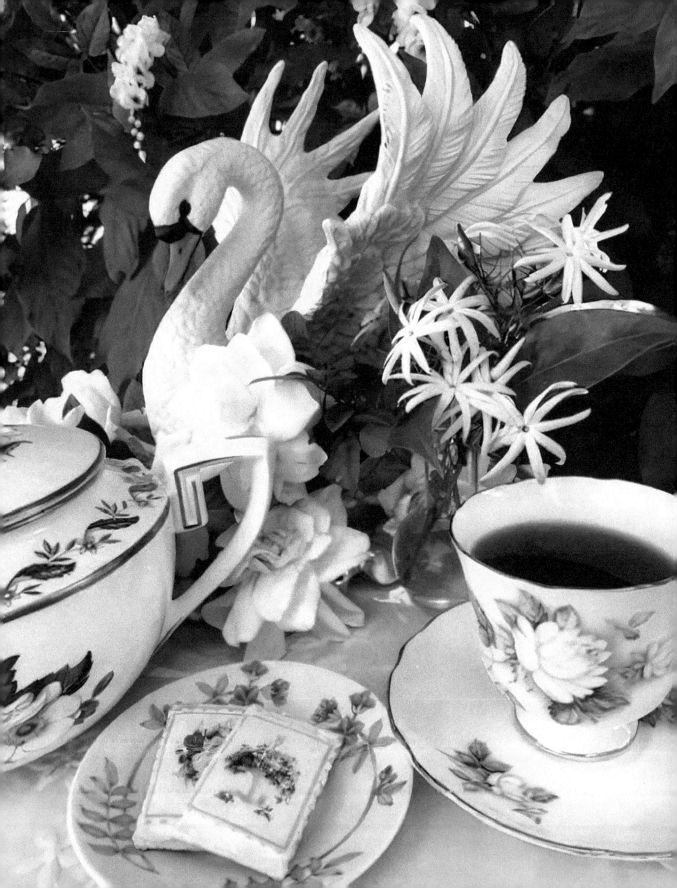

Tea with a Swan

For a few short weeks, when our summer rains usher in every sunset, and heat mirages radiate off every pavement, my yard bursts full of white flowers. The heavily laden gardenia bush wafts sweet perfume to the end of my driveway. Nearby, the jasmine hedge, not wanting to be outshined, raises its regal head, laden with a flowery crown, demanding attention. With all these sweetly scented white flowers at their peak, it's a perfect invitation for an early morning alfresco tea.

Together let's carry our tea out in the yard and enjoy the scent of the flowers while we talk over tea. Picking some of the jasmine to put in a vase on our table and bringing a vintage wrought iron set outside is an inviting start. This lovely white porcelain swan will be the perfect centerpiece. Let's put a pink tablecloth on the table and surround the swan with a ring of our freshly-picked gardenias.

The teapot for our white theme tea will be this Royal Worchester Bernina teapot given to me years ago. It has delicate white flowers that look like an old-fashioned species of rose. It will go beautifully with this Duchess Ice Maiden teacup. The tiny rose buds on the teacup look like they hopped right off the teapot. All we need now is a tasty treat to go with our Harney & Sons Paris tea, which is one of my favorites.

Our tea treats are cookies that I made and decorated with edible rice papers in a beautiful floral motif. These beauties can be ordered from a company called Fancyflours and shipped to your home. They are made with rice flour, sugar, and food-safe coloring and are easy to use and very tasty.

While we sip our tea and enjoy the scent of the flowers, let's have a heart-to-heart chat. Tea time is such a great way to connect and share our struggles with one another. The circumstances in our changing world can make us feel stressed and irritable at times. All of us have moments when we need to repent of sinful reactions, allow our souls to relax in God's presence, and get our attitudes lined up with the truth of God's Word.

Sipping my tea, and sharing these thoughts with you while looking at these beautiful white flowers reminds me of the scripture in Isaiah 1:18 *"... though your sins be as scarlet, they shall be as white as snow"* (KJV). Perhaps, as we chat over this white-theme tea today, we can allow the Holy Spirit to speak to us about forgiveness of sin. He is always ready to reveal the depth of who He is ... if we are still and listen.

So, pour yourself another cup of tea, take a bite of this lovely cookie, sit back in the cool breeze, and inhale the sweet scent of pure white flowers. I have another story I want to share with you.

Coffee Spill
Devotion

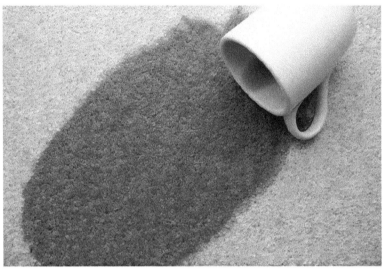

Then I acknowledged my sin to you and did not cover up my iniquity.

I said, "I will confess my transgressions to the Lord."

And you forgave the guilt of my sin.

– Psalm 32:5, NIV.

It was New Year's Eve several years ago, and I found myself with a few quiet hours of reflection time. Although I drink tea in the afternoon, I like a cup of coffee in the morning. I had just sat down with a large mug, breathed a sigh of contentment, and reached for my Bible to prepare myself for the coming new year … when it happened! With one quick swoosh of my arm, the coffee cup went flying, and the entire contents spilled on my light beige living room carpet.

Thankfully, I had learned years ago how to sop up a spill before it became embedded into the fibers. The coffee floated in a puddle on the top of the carpet and had not yet descended into the foam padding underneath. As I carefully laid the towel on top of the dark pool and watched it drink up the stain, my spirit quickened. I knew that God was trying to get my attention. He loves to speak to us through the ordinary events in our day. I began to ask the Holy Spirit what He wanted to show me through this mishap of spilled coffee on my carpet.

I continued sopping up the wet stain and then smiled to see that my carpet appeared fresh and new again, with no sign of the mishap. I was so grateful that I had not allowed the stain to seep in deeply and become embedded into the fibers of the carpet and the foam padding underneath.

Create in me a clean heart, O God;

and renew a right spirit within me.

— *Psalm 51:10, KJV*

Suddenly the warmth of my heavenly Father's pleasure came over me, and His truth permeated my mind. He was showing me that in our lives, spills will happen. They happen to all of us: an ungrateful thought, an unkind word, a quick reaction. We know that these are sins that can stain our lives, but we don't have to let the stain of sin sink in deeply.

God has shown us in His Word that if we call upon His Holy Spirit immediately, before the stain of sin gets deeply embedded into our lives, it is less difficult to remove. There is no big sin and little sin. Sin is sin! But our Savior is all mighty and all-powerful, and no sin, surface or deeply rooted, is any match for the stain-removing power of the blood Jesus shed on Calvary.

My coffee spill disaster reminded me that spills are easier to clean up if we get to them quickly. In the same way, we need to run to our Savior at the first spill of sin, the first unkind thought, the first unkind word. We shouldn't let any sin sit and seep deeply into the fibers of our lives.

In the Psalms, David showed us how to stay on top of those sin-spills when he prayed, *"Create in me a clean heart, O God; and renew a right spirit within me"* (Psalm 51:10, KJV). I believe that God wants us to pray this prayer on a continual, moment-by-moment basis, every day before the spills of sin soak deeply into our souls.

What a merciful and loving heavenly Father we have, that His love would provide such great salvation through Jesus Christ our Lord, and that through His shed blood on Calvary, the stain of sin, can be completely removed!

Come now, and let us reason together, saith the

Lord: though your sins be as scarlet, they shall

be as white as snow; though they be red like

crimson, they shall be as wool.

—*Isaiah 1:18, KJV*

If we confess our sins, He is faithful and just to forgive us our sins and cleanse us from all unrighteousness.
– 1 John 1:9, KJV

PRAYER: Oh, Lord, thank You that You make all things new. I ask that Your Holy Spirit quickens me as I submit to You. Teach me to give all my sins and temptations to You immediately. Enable me to trust in the work of Your Holy Spirit to convict me of sin so that I may ask Your forgiveness before it gets embedded in my life. Amen!

CALL TO ACTION: Begin the daily habit of immediately whispering a quick prayer of repentance at the first sign of a "spill" of sin. If you begin to spill a sinful thought, an unkind word, or a deed that isn't pleasing to your heavenly Father, call upon His stain-cleansing power immediately. If you know that you have the stain of a deeply embedded sin, don't despair. Run to the Savior in prayerful repentance. He is loving and faithful to forgive us our sins and to cleanse us from all unrighteousness.

FOR FURTHER ENCOURAGEMENT: 1 John 1:9, Isaiah 1:18, Psalm 32:5, Acts 3:19, and 1 Corinthians 15:57

Write here about a time when you failed to ask God for forgiveness:

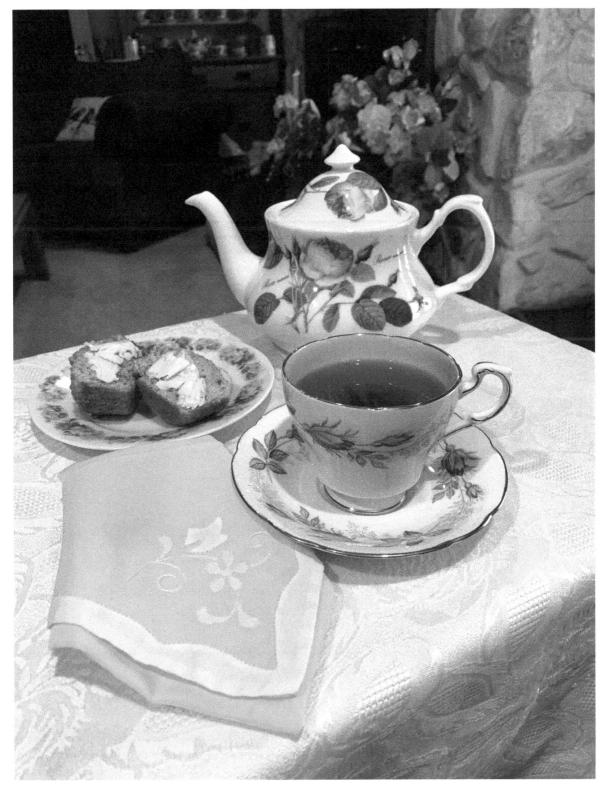

Now repent of your sins and turn to God, so that your sins may be wiped away. Then times of refreshment will come from the presence of the Lord, and he will again send you Jesus, your appointed Messiah.
– Acts 3:19-20, NLT

But thanks be to God, who gives us the victory through our Lord Jesus Christ.
Therefore, my beloved brethren, be steadfast, immovable, always abounding in the work of the Lord, knowing that your labor is not in vain in the Lord.
1 Corinthians 15:57-58, NKJV

Freedom Celebration Tea

Summer is in full swing in all its July glory as you join me for our teatime today. Here in Florida, it's the month for swarms of mosquitoes and afternoon thunderstorms. Just this morning I had to outrun a cloud of mosquitoes chasing me to my mailbox! Safely back inside now, it's time to meet with you for a red, white, and blue theme for afternoon tea.

All across the USA, July is the month we celebrate the birth of our American Independence. Most of us enjoy family picnics, barbecues, parades, and fireworks, but at the core of all the celebrations, we are thanking God for our freedoms. No matter what country you live in, if you are a believer in Christ, you can take joy in the Scriptures that reveal the freedoms God has so marvelously granted all of us as His children.

For our teatime today, we have patriotic music playing triumphantly in the background, while fireworks are being set off all over town. This blue stoneware teapot discovered at a local thrift store perfectly matches our blue linen napkins and white stoneware napkin rings. This fun red check tablecloth makes us smile as we sip our tea from this vintage Blue Danube teacup. Our American flag and a regal eagle sculpture take center place on our table. Also on the table, I'm showcasing a few items that represent our founding fathers, and the men who fought to keep their vision of freedom alive. One item is a photo of my uncle who fought in both great wars, standing in front of the thought-provoking Iwo Jima statue in Alexandria, Virginia. He represents all the others who went before us to maintain our God-given vision of freedom.

Now that the table is set, let's bring out the food. What summer celebration would be complete without some cool refreshing fruit? This blueberry and raspberry fruit tart is layered over a cream cheese custard on a crunchy graham cracker crust. Let's serve our fruit tart with Lady Grey tea. It combines orange peel, lemon peel, and just enough bergamot to give it a gentle balance of spice and citrus. We will also enjoy some bright red, thirst-quenching watermelon wedges threaded onto bamboo skewers.

Everyone who has attended afternoon tea at my house knows that quite often I put scripture cards, or quote cards, at each place setting. Everyone loves to take turns going around the table reading their scripture or quote card while we all enjoy the food and tea together. Today, during our time together, we are going to do just that.

I hope you have your cup of tea ready with your favorite savory or sweet to enjoy while reading and imagine you're at the table with me. Today during our freedom-celebration teatime, we have Bible scriptures on freedom and quotes from our American founding fathers to read. Hopefully, all of you will be inspired or encouraged as we read. While sipping our tea, listen to a story I share about an embarrassing moment and what God taught me as I made an unexpected U-turn.

— Scriptures from the Holy Bible about Freedom —

So if the Son sets you free, you will be free indeed.
— John 8:36, NIV

In him and through faith in him we may approach God
with freedom and confidence.
— Ephesians 3:12, NIV

I will walk about in freedom, for I have sought out your precepts.
— Psalm 119:45, NIV

You, my brothers and sisters, were called to be free. But do not use your freedom
to indulge the flesh; rather, serve one another humbly in love. For the entire law is
fulfilled in keeping this one command: "Love your neighbor as yourself."
— Galatians 5:13-14, NIV

But now that you have been set free from sin and have become slaves of God, the benefit you reap leads to holiness, and the result is eternal life.
— Romans 6:22, NIV

Live as people who are free, not using your freedom as a cover-up for evil, but living as servants of God.
— 1 Peter 2:16, ESV

... where the Spirit of the Lord is, there is liberty.
— 2 Corinthians 3:17, KJV

... through Christ Jesus the law of the Spirit who gives life has set you free from the law of sin and death.
— Romans 8:2, NIV

— Quotes from our Founding Fathers on Faith and Freedom —

Stock Photo

"We hold these truths to be self-evident, that all men are created equal, that they are endowed by their Creator with certain unalienable Rights, that among these are Life, Liberty and the pursuit of Happiness."
— Declaration of Independence, 1776

"The liberty enjoyed by the People of these States of worshipping Almighty God, agreeable to their Consciences, is not only among the choicest of their Blessings but also of their Rights."
— George Washington, First President of the United States

"... God, who gave us life gave us liberty. And can the liberties of a nation be thought secure when we have removed their only firm basis, a conviction in the minds of the people that these liberties are of the Gift of God?"
— *Thomas Jefferson, Third President of the United States, and signer of the Declaration of Independence*

"Freedom is not a gift bestowed upon us by other men, but a right that belongs to us by the laws of God and nature."
—*Benjamin Franklin, Signer of the Declaration of Independence and the United States Constitution*

"It cannot be emphasized too strongly or too often that this great nation was founded, not by religionists, but by Christians; not on religions, but on the gospel of Jesus Christ.
— *Patrick Henry, ratifier of the Constitution*

"Here is my Creed. I believe in one God, the Creator of the universe. That he governs it by his Providence. That he ought to be worshiped."
—*Benjamin Franklin, signer of the Declaration of Independence.*

Unexpected U-Turn
Devotion

Be kind and compassionate to one another, forgiving each other, just as in Christ God forgave you.
—Ephesians 4:32, NIV

After a long and trying day at the office, I came home exhausted, feeling like a beaten kitten that had just escaped a tussle with the neighbor's dog. I still had some things to do before I could relax for the evening, so, kicking my shoes off at the door and throwing my purse down on the sofa, I dragged myself to the computer to review my checking account online. Fear gripped me when I saw not just 1, but 4 overdraft charges. Fighting back panic and reminding myself that it was just a mistake, I picked up the phone and called the bank.

The bank teller who usually works with me proceeded to tell me that he was too busy to tend to this matter and didn't have time for me at that moment. Usually, I'm a very patient person, but something out of character began to well up inside of me at his remark. Since I was already exhausted and troubled by other things I was dealing with, his reply quickly set me on edge. Immediately, I grabbed my purse, flew out the door, and drove to the bank to confront this man.

And as for you, brothers and sisters,
never tire of doing what is good.
– 2 Thessalonians 3:13, NIV

He was quietly sitting at his desk, and upon seeing me walk in the door immediately motioned for me to approach his office. Calmly, but with a stern tone of voice, I reprimanded him, saying that if I had spoken to one of my customers in the manner he had spoken to me, I would expect that they would go elsewhere. Apologetically, he began correcting the bank's error. As he did so, his demeanor became very downcast, and I knew that my stern reprimand had affected him, changing his countenance profoundly.

A few moments later, I was triumphantly in my car, driving home, but the Holy Spirit was working on my heart. Sensing a feeling of conviction, I knew that I had to turn around, go back, and apologize to this gentleman. I hadn't necessarily done anything wrong. It was, in fact, the bank's error, but the thought occurred to me that if I wanted to be salt and light to this gentleman and witness the love of Christ to him in the future, I needed to be sure that his spirit was open to me. Wanting to heed the Holy Spirit's voice, I immediately made a fast U-turn and drove back to the bank.

As I approached, I saw the man outside walking to his car, preparing to leave for the day. His demeanor was downcast, and when I saw him, I knew that my stern exhortation was the cause. As my car pulled up beside him, I rolled my window down and watched his face turn pale. I'm not sure what he expected at that moment, but from the look on his face, I'm sure he was anticipating something unpleasant. I stopped my car right beside him, opened my door, and smiled, humbly extending a hand to shake, and quickly said, "I owe you an apology. I came in here very accusatory, but it wasn't your fault. Will you please forgive me?"

Upon hearing these words, his facial expression quickly changed, and it was apparent that he was shocked and not accustomed to this kind of interaction with a banking customer. He revealed that he was indeed feeling upset about our meeting earlier and then proceeded to smile, followed by letting out an audible sigh of relief that I knew was setting both of us free of any hard feelings.

When the apostle Paul told us in Ephesians 4:32, *"Be kind and compassionate to one another, forgiving each other,"* it was a mandate for every moment of every day, even in the small matters, not just for the gross offenses. Paul was saying that God wants us to walk through daily life with a compassionate and forgiving nature. That doesn't come naturally to sinful humanity. Most of us live quite selfishly, being controlled mostly by our own wants and needs. But when we allow the Holy Spirit to speak to us and turn our hearts toward obedience, He will accomplish in us what we cannot do without Him.

I may never know exactly what went on in that man's heart and mind when I apologized to him in the parking lot. But I do know that my unexpected U-turn and subsequent offering of humility had a significant impact on his life that day. More than that, it impacted my life too, changing how I react to the unforeseen challenges that can happen in our daily lives.

My friends, U-turns are inconvenient, but they are sometimes needed to get us back on track. Take another look at the quotes we read earlier from our nation's founding fathers. Our country could benefit from a repentant U-turn right now. This 4th of July and often, let's all intercede on behalf of our country, as well as the rest of this hurting world. Let's all turn our thoughts back to remembering our Christian ideals. We need to join together to call on God to heal our land. When we have repentant and humble hearts, He hears and He heals.

Then if my people who are called by my name will humble themselves and pray and seek my face and turn from their wicked ways, I will hear from heaven and will forgive their sins and restore their land.

— 2 Chronicles 7:14, NLT

with all humility and gentleness, with patience, bearing with one another in love,

– Ephesians 4:2, ESV

PRAYER: Heavenly Father, forgive us for those moments when we get filled with our selfish pride that may cause offense to others. Thank You for forgiving us and sending Your Holy Spirit to conform us to Your will. We ask You to continue Your great sanctifying work in our lives, so that we might better glorify Your name. Father, remind us that everyone we encounter in life may be someone who needs to know You as Savior. Make us humble instruments of Your grace, and use us to further Your Kingdom. Amen!

CALL TO ACTION: Think of a moment in your day when you know you could have been kinder in a given situation. Now whisper a prayer asking God for forgiveness. Then, if possible, seek out that person and make amends. You will be surprised at how light you will feel afterward.

FOR FURTHER ENCOURAGEMENT: Proverbs 11:17, Galatians 6:10, Ephesians 4:9, 2 Thessalonians 3:13, and 2 Chronicles 7:14.

Write here about a time God showed you to make a u-turn:

As we have therefore opportunity, let us do good unto all men, especially unto them who are of the household of faith.
–Galatians 6:10, KJV

Therefore it is said, When He ascended on high, He led captivity captive [He led a train of vanquished foes] and He bestowed gifts on men. [But He ascended?] Now what can this, He ascended, mean but that He had previously descended from [the heights of] heaven into [the depths], the lower parts of the earth? He Who descended is the [very] same as He Who also has ascended high above all the heavens, that He [His presence] might fill all things (the whole universe, from the lowest to the highest).
–Ephesians 4:8-10, AMPC

Tea for a Shepherdess

Do you have your kettle on? Find your most beautiful teacup and settle in for a very special teatime.

I believe that parenting is like being a shepherdess. It is tenderly and lovingly shepherding your child's heart, and it is a high calling. This time we are going to enjoy a beautiful teatime to honor and bless all you hardworking moms out there. This is going to be an alfresco drive-through tea, something I have never done before, but am very excited about it. I hope that today's teatime will be a blessing for all of us.

My children are all grown, so I am feeling especially nostalgic for this particular teatime. I'm going to bring out this vintage child-sized pink wicker set that my children and grandchildren played on. For our drive-through tea, I chose to bless someone with very young little girls that would enjoy teatime on the wicker. Rebecca and her two daughters came to mind and they were delighted to receive the invitation for my first drive-through afternoon tea. Rebecca brought her mother with her, making it a three-generation Mother-Daughter tea, the first they'd ever had together with the girls. What a special blessing!

The sun was warm, the sky brilliant blue, and there was a gentle breeze blowing. It was a beautiful day to set a tea table and my vintage child-size wicker settee outside in my front yard. I set the table with beautiful bone china teapots and teacups, even putting a little bone china demitasse cup out for the youngest to use. Vintage embroidered linen napkins and lace and crocheted tablecloths on each table were so lovely against the lush green background.

The three-tier server was filled with chicken salad croissants, egg salad on honey oat, carrot and raisin salad cups, and grapes and strawberries. I especially enjoyed making these white chocolate cameo candies for the petite fours using the mold that my daughter gave me. I think these lovely candies will make frequent appearances at my teas in the future. Once I had the tea set up, I notified the women to drive over with their young girls, and then I went inside the house as they drove up to their very own private drive-through teatime. I think this is the first afternoon tea I have prepared but not attended.

Peeking out my window, I could see the women were smiling and watching the little ones enjoying their tea. Even the one-year-old sipped from a china

teacup, and the young girls had great fun using my grandmother's antique silver tongs for the sugar cubes. I think a few sugar cubes were relished before they made it into the tea!

The drive-through tea was a success, and I was delighted knowing that I had brought such joy and blessing to this mother, grandmother, and young girls. I knew that by blessing this one family, it would bless all of us as we enjoyed this lovely scene.

One of the things closest to my heart is the high calling of mothering. I am blessed with an amazing son and two talented daughters, and God gave me even more children to love as our children now have spouses and children of their own. I believe that every woman, no matter her age or stage of life, is a shepherdess. Let me explain.

Several years ago I wrote an exhortation to encourage all mothers in the calling of shepherding their child's heart, and I would like to share those words with you during our teatime today.

Go ahead and pour yourself a second cup and help yourself to your favorite teacake. Get comfortable and let me encourage you with today's devotional words. You will want to have your Bible ready because there are some scriptures at the end that will speak to the heart of each of you.

Fear not, little flock, for it is your Father's good pleasure to give you the kingdom.
– Luke 12:32, ESV

My sheep hear my voice, and I know them, and they follow me.
– John 10:27, ESV

The Ministry of Mothering
Devotion

Lo, children are an heritage of the Lord:

and the fruit of the womb is his reward.

– Psalm 127:3, KJV

In an instant, your whole world is changed. A child is placed into your arms, and suddenly you are thrust into the greatest adventure, the biggest challenge, and the most powerful ministry that God has given to women – the ministry of mothering!

Maybe you never thought of raising your children as a "ministry," but God has called you to impact the life of the children that He created. You are to mold them to be effective for His eternal kingdom, and that is one of the highest of all callings.

Biblical mothering is an honored and privileged ministry that has relentless demands, but you are not powerless for this task, for with it comes a special anointing from God Almighty. He calls you and empowers you for this great adventure.

Shepherding your child's heart under the guidance of the Holy Spirit is a powerful force that can shape, not only the life of your child, but through that child's life, can change an entire city, future generations, a nation, and even the whole world.

It has been written "a mother's love outlasts all other human loves, her faith endures the longest hardest test" and "no language can express the power, beauty, heroism, and majesty of a mother's love."

Greater love has no one than this:
to lay down one's life
– John 15:13, NIV

All your children will be taught by the Lord,
and great will be their peace.

– Isaiah 54:13, NIV

Render therefore to all their dues: tribute to whom tribute is due; custom to whom custom; fear to whom fear; honour to whom honour.
– Romans 13:7, KJV

Being a mother may, at times, call for laying down your dreams to pour yourself into molding the lives entrusted to you. Day after day, you faithfully keep on giving, serving, and meeting the needs of your children, regardless of your own needs. You pour every fiber of your being into the task of loving and raising your children, suppressing your own needs for the greater love for your child. Parenting is an expression of what Jesus called *"greater love." "Greater love hath no man than this, that one lay down his life …"* (John 15:13, KJV).

Mothers, be encouraged that God sees you. He sees the times you give up sleep to pray through the night for your child. He hears your agonizing cries to rescue the wayward one, to heal the sick one, or to show Himself strong to the child who is seeking Him. God knows that, for you to love your children with the kind of sacrificial love that mothering requires, you need His grace and His anointing for this lifelong calling,, and He pours it out to you in abundant measure as you seek His guidance.

No matter what season your mothering is in, whether it's the diaper-changing years, the education years, or the letting-go years, once you are a mother, you will carry that ministry in your heart throughout your lifetime. You are always praying for the lives that God has placed in your care. Remember, God blessed you with your specific children because no one else could impact their lives the way you do. No one else can pray for them as powerfully as you can. Even when your children are grown, your faith and your prayers can continue to greatly impact their lives.

Moms, have confidence that God sees you. Have confidence that He hears and that He rewards you as you seek Him for your children. If you struggle with feeling like you are not effective, remember that there's no such thing as a perfect mother, only mothers who are perfectly dependent upon the Lord for every moment of the journey.

Romans 13:7 says *"Render therefore … tribute to whom tribute is due; honor to whom honor is due;"* so today, mothers and grandmothers, we honor you. Whether your children are of your womb, or of your heart, whether you are just starting on this journey, or seasoned by many years of mothering, take a deep breath. God's anointing is powerfully available to you for all that He calls you to, in this Ministry of Mothering.

As a mother comforts her child, so will I comfort you; … .
– Isaiah 66:13, NIV

... I have learned the secret of living in every situation, whether it is with a full stomach or empty, with plenty or little. For I can do everything through Christ, who gives me strength.
– Philippians 4:12-13, NLT

PRAYER: Father God, thank You that You have trusted us to mold the lives of our children. In the midst of our busy daily routines, help us remember that mothering our children is a high calling. Lord, we pray that You would enable us to fully trust You for the daily strength and wisdom we need for this task.

CALL TO ACTION: Begin each morning with a prayer of thanks for your children. Each day this week, read one of the scriptures below and remind yourself that you are not just a mom; you have a ministry as you mother your children. If you aren't a mother yet, you still have a ministry to touch the lives of the children God brings you into contact with. What a blessed privilege!

CALL TO ACTION: Begin each morning with a prayer of thanks for your children. Each day this week, read one of the scriptures below and remind yourself that you are not just a mom; you have a ministry as you mother your children. If you aren't a mother yet, you still have a ministry to touch the lives of the children God brings you into contact with. What a blessed privilege!

FOR FURTHER ENCOURAGEMENT: Philippians 4:13, Proverbs 22:6, Ephesians 5:2, 2 Timothy 3:15, 1 Corinthian 13:4-8, Proverbs 31:26, 2 Timothy 1:5, Deuteronomy 11:18-20, Hebrews 11:6, and 2 Corinthians 12:9

Write here something about a time when God helped you to bless others:

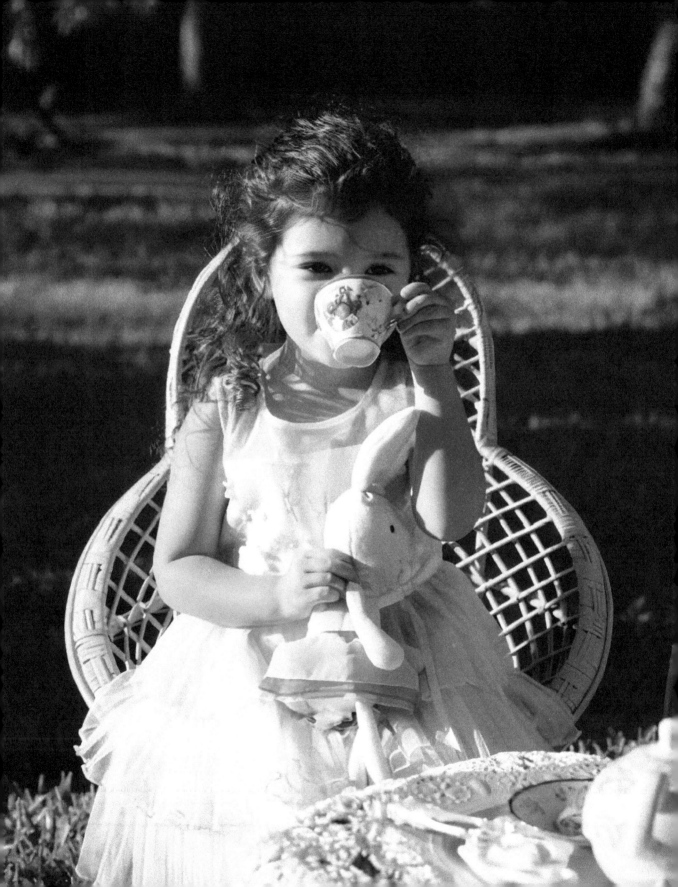

Train up a child in the way he should go:

and when he is old,

he will not depart from it.
– Proverbs 22:6, KJV

I can do all things through Christ

who strengthens me.
– Philippians 4:13, NKJV

Follow God's example, therefore, as dearly loved

children and walk in the way of love, just as Christ

loved us and gave himself up for us as a fragrant

offering and sacrifice to God.
– Ephesians 5:1-2, NIV

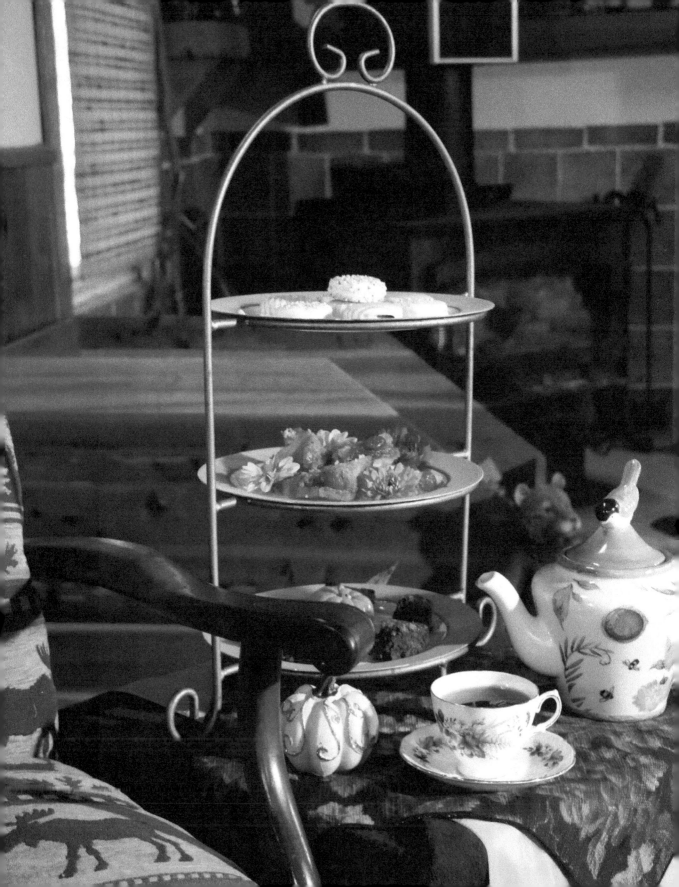

Tea at the Cabin

Adobe Stock Photo

If your soul needs a quiet retreat, this is your moment! On this crisp autumn morning, as the leaves blanket the land with a gold and crimson glow, I'm going to treat you to teatime in the woods of the Great Smoky Mountains. It's easy to see how this area, which spans across eastern Tennessee and western North Carolina, got its name. It's fascinating to travel through miles of foothills enjoying views of the higher elevations, which are surrounded by a soft bluish haze in the distance. It's as if the mountains are rising out of a sea of dusty blue cotton candy. Here, tucked away in the foothills of this picturesque land, is a dreamy cabin that invites us to let our cares melt away.

We approach our special teatime getaway through a long, winding, leaf-covered trail. Up a hill, and around a bend, through brilliant fall foliage, we finally come upon this captivating view. Tucked amongst the golden leaves in a thick forest of birch trees, the first glimpse of our cabin comes into view.

The first thing we notice through the clearing is the inviting half-moon window perched high in the peak of the A-frame. We immediately sense there is something special about this place. This little cabin, nestled amongst sweet gum trees, red oaks, white pines, and hundreds of golden birch trees, was built with much love and hard work by my aunt and uncle. They milled their siding for the walls using fallen poplar trees from their property and put much care and attention into creating an oasis of peace and tranquility for family and special occasions like the afternoon tea you will enjoy today.

The front porch greets us with this whimsical moose bell hanging beside an original 1950s Maytag wringer washer. There are so many thoughtful details, inviting simplicity and relaxation. I love the little pond they dug beside a huge red oak tree and stocked with largemouth bass, bluegill, and catfish. At certain times of the year, a pair of colorful wood ducks or a family of geese will announce their arrival by gliding to a graceful landing, decorating this tiny pond with the ripples of their presence on the water. Sounds of crickets, katydids, and grasshoppers, the music of the land, keeps in tune with the crunching of the leaves under our feet.

It's cool this morning, so we're going to start our teatime inside, relaxing in a cozy chair next to the wood-burning stove. The chickadee teapot and Royal Vale Autumn Leaves teacup are perfect for our tea at the cabin. The three-tier server is filled with pumpkin spice macaroons coated with a maple drizzle, apple strudel coffee cake, a few grapes, and chocolate brownie squares. A simple English Breakfast tea warms us, as we enjoy our treats.

After our first cup of tea, the fire dies down, and the afternoon sun warms the air, so let's move outside and blissfully sip our second cup of tea relaxing under the trees. While you sip your tea and enjoy the scenery in this special place, I want to tell you of a time when our family drove the higher elevations of these mountains and discovered that heeding God's nudge to worship and praise Him gave us victory over a very dangerous situation.

The Power of Praise
Devotion

It had been years since we had made the trip from Florida to North Carolina to visit my parents. Excitement radiated from the faces of our three school-age children, as they loaded our van with their toys, sleeping bags, and snacks for the trip. Escaping the relentless Florida heat to enjoy cooler weather with autumn foliage and a visit with GG, as the children called my mother, was always a much-anticipated family vacation. My husband securely attached a pop-up camper behind our 1985 Dodge cargo van, as I put our atlas and road maps in the front seat. The van was a newly purchased work truck that only had two front seats and had not been fitted with shelving or tools yet, so we filled the large open floor space with a mattress for the children to play and sleep on. Those were the days before seat belts were mandated, when a paper map was our only guide, and when children could move freely in a vehicle. Finally, ready to hit the road, we said goodbye to beaches with palm trees and headed for mountains with maple trees.

As we traveled, we played our favorite road trip games, like watching for a certain color car or naming state license tags, but mostly we sang songs. My husband would lead us in silly songs and old tunes like Grandma's Feather Bed. Sometimes we would sing familiar worship songs, and we kept the van's cassette player busy playing a variety of children's praise and worship music we had brought with us. Our children all love to praise the Lord and have a heart to worship God, so the singing in that van was loud and heartfelt.

After a few days of traveling, my mother's house came into view, and we had a wonderful visit. But, on our last night there, I couldn't sleep. A restless feeling came over me, and I remember lying in bed asking God to give me rest, but sleep never came. Sometime during that long night, I began to feel even more restless, almost apprehensive about something. As I began praying, I felt a distinct nudging from the Holy Spirit, and it seemed as if the Lord was speaking to my mind the words: "Just keep praising Me!"

The next morning, we hugged my parents goodbye, got into our van, towing the camper behind us, and

119

About midnight Paul and Silas were praying and singing hymns to God, and the other prisoners were listening to them. Suddenly there was such a violent earthquake that the foundations of the prison were shaken. At once all the prison doors flew open, and everyone's chains came loose.
– Acts 16:25-26, NIV

headed across the Blue Ridge Parkway to camp for a few days. Anyone who has traveled that road knows that as the elevation climbs higher, the views become ever more spectacular. We could look out the window and see steep drop-offs only a few feet from the edge of the road. As my family became more excited about the views, I became more and more restless. Remembering what the Holy Spirit had told me during the night, I put on my favorite cassette with Steve Green worship music to create an atmosphere of praise, and soon my husband was singing along with me. The thought from my sleepless night—"Just keep praising me! Just keep praising me!" kept ringing in my mind over and over again. I didn't know why the impression was so intensely powerful inside of me, but if God was giving me instructions, I wanted to obey. So I prayed, sang songs, and praised the Lord for miles, encouraging the family to join me in praise and worship.

Suddenly, I found myself feeling very calm. I remember sitting back and thinking, "This is the moment the Lord told us to be praising Him for." Then it happened! Our van started skidding on wet mud on the side of the road. The weight of the camper being towed behind us made it difficult for my husband to keep the van steering straight on the road, and we started veering toward the edge of the cliff. In a split second, I knew our lives were in danger, and I knew that this was why the Lord had wanted us to spend the trip praising Him. There is power in praise!

It all happened in a split second. The van skidded off the road, the front of the van started taking a nosedive down the hill, and then ... it just stopped! After taking a deep breath, we realized that the front of the van was teetering just off the edge of the hill, while the camper was still partway on the road. The only thing that appeared to keep our van from tumbling more than

6,000 feet down the cliff was two tiny saplings that the front bumper was touching. But those saplings weren't big enough to hold a clothesline, much less stop a van pulling a camper.

As the van teetered half on the road with nose pointed down the cliff, my husband sprang into action. He opened his door and leaned his weight out the door to steady the van, while instructing each of us to crawl out of the van on his side, which was on the opposite side as the edge of the cliff. One by one we safely exited the van and stood on the road looking at our van wobbling dangerously.

With no cellphones and no way to call for help, we waited for a car to pass by. Eventually, someone stopped and told us they would drive over the mountain to the next town and send a tow truck back for us. How long that took I don't remember. But what I do remember is dropping to my knees in thanksgiving and watching the different reactions of each of my children and my husband as they processed what had just happened ... and what could have happened. All of us, in our own way, worshiped the Lord in that moment and recognized God's hand of protection upon us. It wasn't a sapling that stopped our car from tumbling down that cliff; it was the hand of God! There is a wonderful truth that God taught our entire family, from the youngest to the oldest, through that event. Praising Him is powerful!

I may never know what battle was going on in the heavenly realm during that dangerous event, but there are two things I know for sure: 1). When the still, small voice of God is whispering to you, it is best to obey, and 2). When the enemy is trying to destroy you, praising God releases power to defeat him.

The Bible story of Jehoshaphat, King of Judah, tells of an instance when praising God before a battle gave

victory to God's people as an enemy was trying to destroy them. In 2 Chronicles 20, we read that a great multitude from Syria came against Israel. In response to this dangerous situation, Jehoshaphat and all God's children entered into a time of prayer with worship and praise. *"Jehoshaphat bowed down his face to the ground, and all the people of Judah and Jerusalem fell down in worship before the LORD"* (Verse 18, NIV). They knew that if they submitted themselves to the sovereignty of God's protection and entered into praise and worship, it would release God's power so they could have victory. What's amazing to me is that God even told them they didn't have to do anything themselves. They just had to praise Him and watch to see what He would do! The word from the Lord was: "You *will not have to fight this battle. Take up your positions; stand firm and see the deliverance the LORD will give you"* (2 Chronicles 20:17, NIV). We are told how they responded: *"Jehoshaphat appointed men to sing to the LORD and to praise him for the splendor of his holiness…saying, 'Give thanks to the LORD, for his love endures forever'"* (Verse 21, NIV).

Another one of my favorite stories of the power of praise is in the book of Acts. Paul and Silas had been flogged and thrown into jail and were shackled by their feet. I can't even imagine the pain and difficulty of what they experienced, but it's even more mind-boggling when we realize they responded by singing praises! *"About midnight Paul and Silas were praying and singing hymns to God, and the other prisoners were listening to them. Suddenly there was such a violent earthquake that the foundations of the prison were shaken. At once the prison doors flew open, and everyone's chains came loose"* (Acts 16:25-26, NIV).

You know the rest of the story. The jailer knew he had just witnessed an act of God and immediately asked what he must do to be saved. When Paul told him to believe on the Lord Jesus Christ, the jailer and his whole household became believers and were baptized. Praising God through difficulty in that jail cell not only set Paul and Silas free from prison shackles; it ushered in the presence of God so powerfully that the jailer and his family came to know the true freedom that comes from salvation in Jesus Christ!

As wonderful as these stories are, we must realize that praising God and worshiping Him is not an action we do just to get something from God. It is an expression of our hearts, an expression of love and adoration that flows out of us toward the One who first loved us (see 1 Chronicles 16:29).

When we realize how much God loves us and we love Him in return, praising Him becomes the natural expression of that love. And in that love, and through that praise, the presence of God becomes mighty and powerful in our lives. Whether we see anything change or not isn't what is important. It is His presence that should be our heart's desire. His presence is the greatest result of praising Him. Won't you take a moment now to praise Him?

Let everything that has breath praise the Lord! Praise the Lord!
– Psalm 150:6, ESV

O Lord, you are my God; I will exalt you; I will praise your name, for you have done wonderful things, plans formed of old, faithful and sure.
– Isaiah 25:1, ESV

PRAYER: Heavenly Father, I take a moment right now to praise and worship You. You are holy, merciful, sovereign, and faithful. You love us with unconditional love, and Your love is powerful over all. Thank You for providing salvation through Jesus Christ our Lord and Savior. Help me to know Your voice and have ears to hear and a heart to respond. Help me to know when You are calling me to praise You, and enable me to obediently respond to Your call to worship. I trust in Your sovereignty over my life and your protective power over me and my family. Amen!

CALL TO ACTION: Everyone has a story of God's faithfulness in their life. If you haven't done it yet, use the space provided at the end of each chapter to jot down an experience from your life in which you believed you heard the voice of God and are thankful that you responded.

FOR FURTHER ENCOURAGEMENT: Psalm 150:1-6, Colossians 3:16, Psalm 100:4, Psalm 115:1, Isaiah 25:1, and Exodus 15:2.

Write here something about a time when God urged you to praise Him.

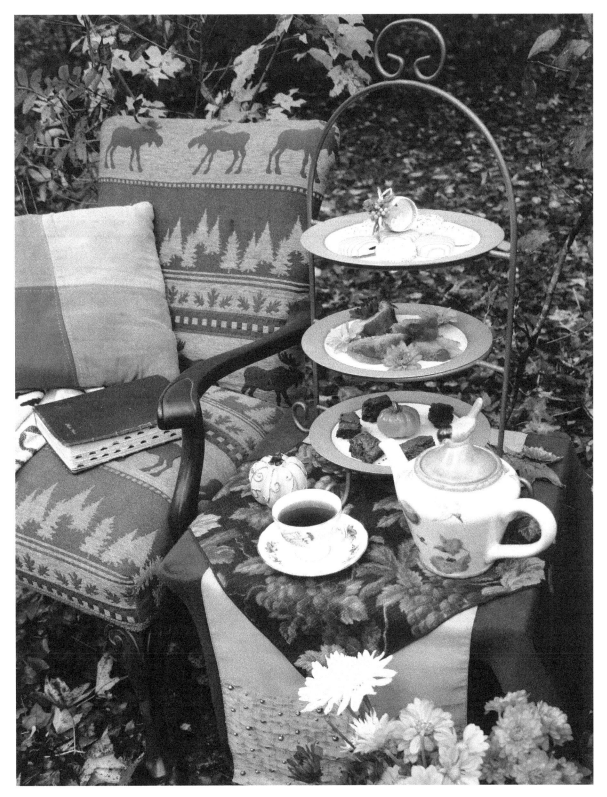

Enter his gates with thanksgiving
and his courts with praise;
give thanks to him and praise his name.
– Psalm 100:4, NIV

The Lord is my strength and my defense;
he has become my salvation.
He is my God, and I will praise him,
my father's God, and I will exalt him.
– Exodus 15:2, NIV

Yet I will rejoice in the Lord, I will joy in the
God of my salvation.
– Habakkuk 3:18, KJV

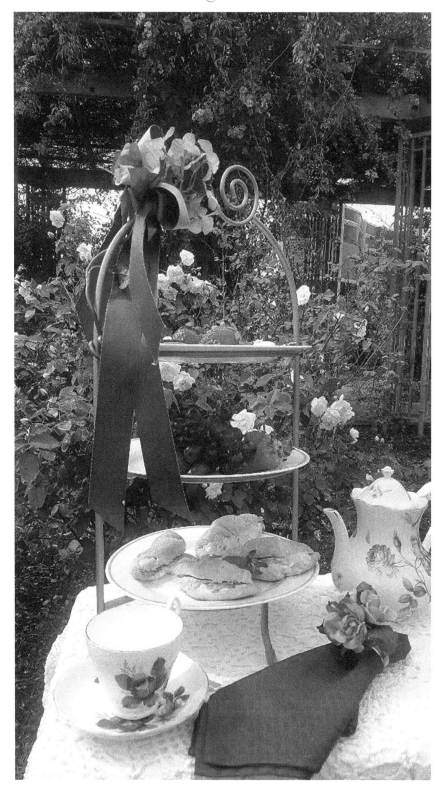

Afternoon Tea at Ruth's Rose Garden

Adobe Stock Photo

Your senses will be delighted as we "stop to smell the roses" for today's afternoon tea. It's a day to put on your favorite summer dress and pack your prettiest teacup to enjoy tea in a most beautiful setting.

Surrounded by color and immersed in a romantic fragrance that's blowing in the wind, we joyfully set our tea table in the middle of Ruth's Rose Garden. This hidden gem is a botanical oasis hidden in the center of the campus of Florida Southern College in Lakeland.

This little rose garden is modeled after classical French rose gardens of the 19th century and is home to some of the most diverse collections of rare roses in the U.S. Admittedly it's not as large and glorious as some of the European gardens, but it impresses with every step we take. With 300 plants of nearly 200 different heritage varieties, it was created for horticulture students to study and work with rare roses to develop plants certified free of diseases like rose mosaic. I am so happy that they let us bring our teatime into the garden today. This rose garden boasts a stunning array of rare varieties including a deep red heritage rose that dates back more than 2,000 years. This small but impressive garden has provided roses to nurseries in Canada, Bermuda, Africa, and the U.K.

As we stroll through this formal little garden with its lovely circular paths and search for a spot to set up afternoon tea, we can't help but be awed by delicate pink roses climbing high above our heads. The vines are so massive and tall that they are supported by huge and intricately shaped geometric domes. Many other climbing roses of all colors seem to dance up and over similar structures scattered among larger rose bushes, all-enveloping us in a dreamy garden room perfect for today's teatime devotions.

For today's afternoon tea, we brought our 3-tier server to the garden, along with a small folding table, a lace tablecloth, and of course, we brought a beautiful bone china teapot and lovely Royal Albert teacups. Setting up as close to a rose bush as we can, we fill our server with both hearty savories and delectable sweets. You're going to love the buttery French croissants on the bottom tier, perfect for this French-inspired garden. We fill them with a refreshing chicken salad made with bits of apple, grapes, pecans, and a tiny sprig of endive. Fresh local strawberries and thirst-quenching grapes will beautify our second tier. For dessert, our chocolate craving will be satisfied with dark-chocolate-covered shortbread cookies placed on the top tier. Both sweets and savories chosen for today perfectly complement our English Breakfast tea.

As we enjoy our teatime, the scent wafting from the roses draped on the arbor above our head is heavenly, and the butterflies are enjoying the roses as much as we are. As one of the butterflies lands on a bright red heritage rose next to me, I am reminded of a time when God used a butterfly to show me to trust His timing.

It's time to pour yourself another cup of tea, have a seat on the bench under the rose arbor, and relax for our afternoon teatime devotion.

Metamorphosis Before Flight
Devotion

Once upon a time, many years ago, I helped my children raise a monarch butterfly for a science project. I remember the sounds of their giggles as they raced through the yard with excitement plucking branches of milkweed flowers containing the young monarch caterpillar. With delicate hands, they carefully carried the branches into the kitchen to put in a specially prepared container where the soon-to-be butterfly could finish the metamorphosis process safe from predators.

Our son had built the container and spent countless hours with his sisters watching the caterpillars chewing the leaves and growing fat. It was an exciting day when they woke up and discovered the caterpillar had transformed into a beautiful green chrysalis decorated with glistening gold dots. For ten days we marveled at the change and watched and waited. During the last few days of the metamorphosis process, the chrysalis became so transparent and clear that we could see the design and color of the wings developing. We were captivated, watching the transformation taking place inside this transparent covering, and our entire family spent hours gazing in awe of God's marvelous ways.

Soon the attempt to start life as an airborne creature began, and the butterfly started wiggling from its confinement. We knew it was time to carefully carry the branch outside into the sunshine and fresh air to watch its emerging freedom. But we soon learned it wasn't a fast process. Watching it struggle was hard for all of us. We wanted to help it out of its confinement, but we knew that if we forced it to emerge at that point, it would have been disastrous! It needed a little more time, a little more basking in the sunshine before it was able to fulfill its purpose.

There was a time I felt like that butterfly. Struggles and circumstances left me feeling in suspended animation, like a butterfly curled tightly inside a cocoon almost ready to emerge. I knew that my life was about to go through some kind of transition into something new and different, and I longed to be able to break free and "fly." For a long time, I sensed being on the verge of a new opportunity, but my daily challenges were confining, and I didn't understand why it was taking so long. The beauty and pattern of what God was forming inside of me was easy to envision, but I couldn't get it into action. Like forcing a butterfly's wings open, I was tempted to go ahead and help God kick-start the new stage of life He was preparing me for. But I also knew that if I forced the circumstances too soon, I would have crippled wings and wouldn't be able to stretch into my new role.

Finally, I decided to allow God to work on my soul and wait. As I immersed myself in His Word and His presence, I became more aware that only God could see the changes that needed to take place inside of me before my transformation was complete and He could let me fly into my calling.

In the Bible, young David must have felt that way while sitting on the side of the mountain tending sheep. He found out that a big change was about to take place in his life. The prophet Samuel had anointed him and told him that he was soon to be transformed from a shepherd to a king. In the Bible we read, *"There is still the youngest," Jesse answered. "He is tending the sheep." Samuel said, "Send for him; … so he sent for him and had him brought in … . Then the LORD said, "Rise and anoint him; this is the one"* (1 Samuel 16:11-12, NIV). Talk about a life-changing metamorphosis!

David was still quite young, and his days were filled with the daily tasks of sheep-tending duties. How could he be transformed into a king? Only God can accomplish that kind of transformation in a person. It would take many years for God to perfect His ways in David before he could walk into this calling. The time of waiting began. God wanted David to sit on the side of that mountain and bask in the light of His love. David needed years of quietness, learning of God's goodness, and becoming familiar with His voice. No one could see what God was doing inside David's mind and heart during this time, but the time lapse between shepherd and king was necessary. During that time, God taught David the similarities between shepherding sheep and shepherding His people. While David was waiting, God worked on his heart in ways that only He can do in a man.

We read in 1 Samuel 16:7 (NKJV), *"For man looks at the outward appearance, but the LORD looks at the heart."* Only God could see what He was forming inside David. It was David's time of waiting in the cocoon of God's purpose, waiting and trusting, while God fully formed him into the man that would be able to lead the people. We have a little peek into what was going on inside David during that time when we read the Psalms. His writings give us a glimpse of that transformative time, the tears he shed, the pain and desperation he felt, and the mighty faith that built up inside of Him during that time of waiting. The transformation eventually did come for David. He became King of Israel and led God's people mightily.

Perhaps you have an awareness that a change is about to take place in your life. Maybe it's a new job or a new child, a new ministry or a relocation. Maybe it's a gifting or calling that you have been waiting to step into. Trust God to perfect the process in you. Trust Him when He is showing you that you need a little more time and a little more basking in His "Son"shine. As you sit in His presence and seek His face you can be confident that He will perfect what He began in you (see Philippians 1:6). It's hard to go through this process, but our Savior, who knows us best and loves us sacrificially, wants us to stop struggling to make things happen and trust Him completely.

Adobe Stock Photo

131

Therefore, if anyone is in Christ,
the new creation has come:
The old has gone, the new is here!
– 2 Corinthians 5:17, NIV

PRAYER: Heavenly Father, forgive me for trying to force Your process. I determine that I will trust You in all things. I know that Your ways are perfect and that Your timing is perfect. Send Your Holy Spirit to give me the patience to wait on You.

CALL TO ACTION: Put a butterfly picture where you can see it every day. Let it remind you to trust God's timing and His transforming power in your life.

FOR FURTHER ENCOURAGEMENT: 2 Corinthians 5:17, Philippians 1:6, 1 Samuel 16:7, and Psalm 138:8

Write something here about patiently waiting for a change that came to your life.

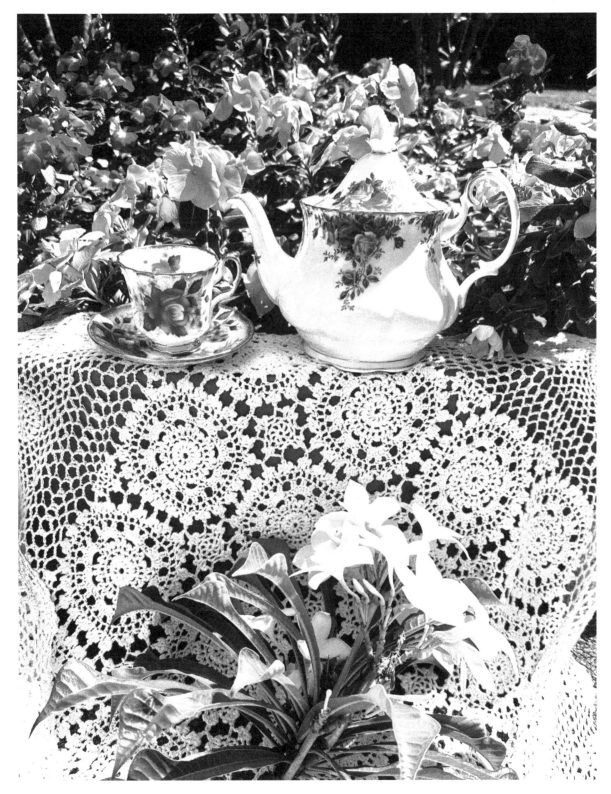

Being confident of this, that he who began
a good work in you will carry it on to
completion until the day of Christ Jesus.
– Philippians 1:6, NIV

But the Lord said to Samuel, "Don't judge by his
appearance or height, for I have rejected him. The Lord
doesn't see things the way you see them. People judge by
outward appearance, but the Lord looks at the heart."
–1 Samuel 16:7, NLT

The Lord will perfect that which concerns me;
Your mercy, O Lord, endures forever;
Do not forsake the works of Your hands.
– Psalm 138:8, NKJV

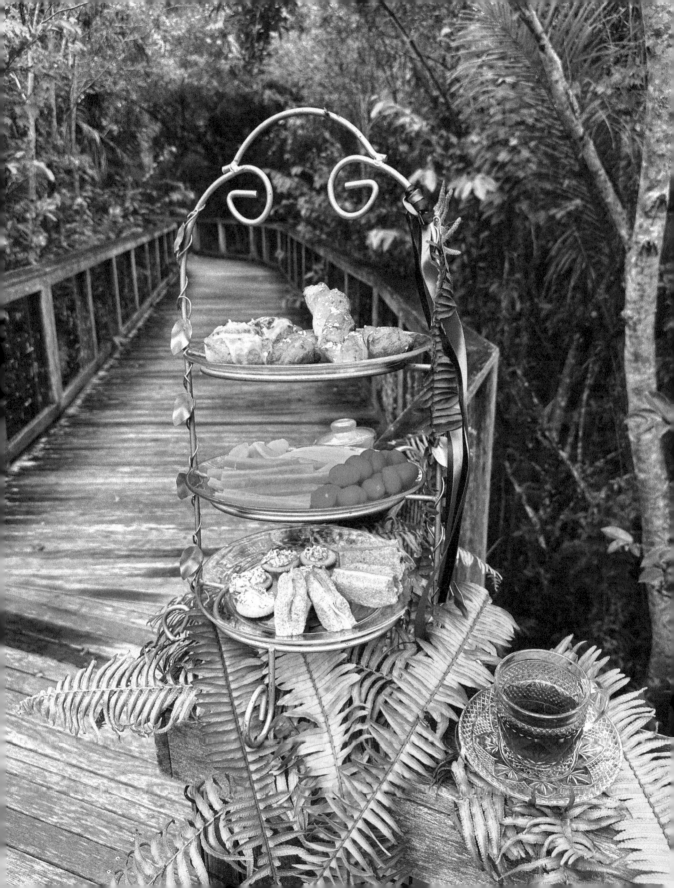

Afternoon Tea on the Nature Trail

Towering cypress trees rising among a deep carpet of lush green ferns are beckoning us for today's afternoon tea. This time we will take tea at a place deep in South Florida where a boardwalk meanders through a conservancy area, perfect for relaxing and observing nature. Our location is the Collier County Freedom Park. This lush, subtropical park consists of fifty acres of wetlands with exotic vegetation, wildlife, and several lakes scattered along more than 3,500 feet of boardwalk elevated above the marsh.

As we approach the entrance of the park, we are greeted by the huge Freedom Memorial made of granite and formed in the shape of a waving American flag. It is 13 feet tall and 40 feet wide and is set over stone replicas of each state. This impressive memorial flag was placed at the entrance of the park to pay tribute to members of our armed forces and those who lost their lives in the September 11, 2001 attack. It is an awe-inspiring sight.

Just beyond the flag memorial, we enter the boardwalk area and immediately sense the quietness of this place. Strolling on the boardwalk carrying our three-tier server and basket of food for our afternoon tea, we pass several plaques identifying native plants with names as exotic as the plant themselves. We enjoy the sight of gumbo limbo trees, pond apple, and coco plum trees. An occasional squirrel can be seen bravely snatching one of the fallen fruits from the boardwalk at our feet.

Hearing a rustling sound, we look over the boardwalk railing and see several rabbits hopping through the palmetto bushes. It has rained recently, so there is an invasion of large lubber grasshoppers visible on most of the trees and bushes. These grasshoppers are extremely colorful and so large that they both fascinate and frighten many visitors not accustomed to this subtropical species. Soon we come to a bridge on the boardwalk that crosses over one of the lakes, and we pause to watch some large fish in the water and a turtle family lined up single file sunning on the banks.

After a slow leisurely walk, let's pause in the shade to set up our three-tier server and fill it with both sweet and savory items to enjoy afternoon tea together. We brought a clear glass teapot and depression glass teacups to pour our Lady Grey Tea into. Spinach and onion dip on crackers and ham and swiss sandwiches with Dijon mustard are on our bottom tier. Next, we cool our palate with refreshing mango slices, carrot sticks, and sweet grape tomatoes. The top tier satisfies our sweet tooth with orange/mango cakes and vanilla/cinnamon twists.

It is so lush and green here that each breath we inhale seems infused with an extra measure of oxygen, and it's so quiet that we can hear every frog and cricket. As I pour another cup of tea, I notice the reflection of light on the cup, and I'm reminded of a story I want to tell you. It is about a time I was taking a walk on this same boardwalk when God revealed one of His marvelous truths to my heart.

Boardwalk Reflections
Devotion

It's not often that we get a cool morning where I live in South Florida, but this was one of those rare, refreshing mornings that beckoned me outside. I decided to walk a nature trail that meanders on a boardwalk through a small swampy area nearby. In the car on the way, I heard a radio commentator read from Psalm 91, *"He who dwells in the secret place of the Most High shall abide under the shadow of the Almighty."* I have always loved the promises of this scripture. As I parked and approached the boardwalk, the phrase *"shadow of the Almighty," "shadow of the Almighty"* kept ringing over and over in my ears.

Oh, how I love this place! Wispy cypress trees growing next to tall purple water hyacinths and delicate white arrowhead flowers thrill my soul. It's a wild place, and every day holds a different sight.

Below the boardwalk, we might see an egret walking among the water lilies or an anhinga wading through the water lettuce. The sweet song of mockingbirds, blending with the shrill call of a hawk, the low grunting of bullfrogs, and the high pitch of crickets create a symphony, and I find myself walking in tune with their music.

This boardwalk is not straight. It twists and turns in many different directions as it skirts around a tree or over a waterlogged area. Sometimes it jets off sharply to one side with a bench provided for pausing and reflecting.

While walking the boardwalk that day, I began to feel as lighthearted as a child. I became intrigued by my own shadow as it stretched out on the weathered planks of the boardwalk. One moment my shadow was in front of me, but at the next turn, it was behind me. Sometimes the boardwalk made turns so quickly that I found myself letting out an audible giggle, and I felt like a child playing with my own shadow, like Peter Pan.

In the midst of my shadow chase, I remembered the scripture that I had heard on the radio while I was driving there, and I knew that God was using this delightful experience with my shadow to reveal a beautiful truth to me. He desires to do this for all of us … if we will listen.

At this point on the boardwalk, the sun was right in front of me, and facing the sun was causing my shadow to fall behind me. At that moment I knew what the Lord was reminding me. In the twists and turns of life, we must always face the Son! If we keep our eyes on the Son of God and walk directly into His light, turning our face toward Him, it puts Him in a place of being able to lead us. In this position, the shadows of our doubts and difficulties fall behind us. This revelation caused a smile to come across my face, while a cool breeze and the smell of a water hyacinth filled my senses. I continued walking, enjoying the sound of the birds and the sight of pale green water lettuce floating in the water below the boardwalk.

Soon I turned another corner, and as I made this turn, the sun fell behind me, and I watched my shadow suddenly appear again. But this time my shadow was stretching long in front of me on the boardwalk. My shadow was now the leader. It was leading me! I began realizing that if I turned away from the Light, putting God behind me, it puts the shadows of my difficulty in the foreground, and the shadow leads. I knew that having the shadows of my problems lead my thoughts and emotions is not a place of peace and happiness, so I slowed my pace to let this truth sink in.

It is so clear in the Bible that God desires to direct our steps and lead us in His ways ... if we will put Him out front. Joseph was a wonderful example of having to keep his eyes on God despite difficult circumstances. If anyone had to learn to look fully into the light of God's face and put the shadows of difficulties behind him, it was Joseph. In the book of Genesis, we read about the rough life and tremendous difficulties Joseph endured.

As the youngest son of the patriarch Jacob, he was despised by his brothers, and they sold him into slavery. The Bible account says: *"So when Joseph came to his brothers, they stripped him of his robe … and they took him and threw him into the cistern"* (Genesis 37:23-24, NIV). Later in verse 28, it tells us: *"So when the Midianite merchants came by, his brothers pulled Joseph up out of the cistern and sold him for twenty shekels of silver to the Ishmaelites, who took him to Egypt."*

In Egypt, Joseph was appointed slave to a high-ranking man named Potiphar but ended up in prison when he was falsely accused. Talk about facing the shadows of trouble! In a situation like that, he had a choice, and that choice was where to focus. He could focus on his difficulties or keep God in the forefront of his heart and mind. And that is what he seems to have done. Why do I say that? Because he was able to hear from God, correctly interpret Pharaoh's dream, and was then appointed to a trusted position of leadership.

Eventually, God used Joseph to save his family and all the people of Israel during a great famine. Joseph experienced a great shadow chase, and he was rewarded for keeping God in the forefront and putting the shadows of his difficulties behind him. My teatime friends, it's all about where we choose to focus, and Whom we choose to focus on. We are given a promise in Isaiah 26:3: *"You will keep him in perfect peace whose mind is stayed on you, because he trusts in you"* (ESV). When the shadows of our difficulties want to rise up in the forefront of our minds, we should remember that the Bible encourages us: *"Set your minds on things above, not on things that are on earth"* (Colossians 3:2, ESV). When we do that, we don't have to chase so many shadows.

It has been wonderful having teatime with you today and reflecting on my boardwalk adventure. Don't you love seeing how moments in life can reveal the most profound truths of the Scriptures? All we have to do is face the SON … and listen.

Through him all things were made; without him nothing was made that has been made.
—John 1:3, NIV

I will sing of the Lord's great love forever; with my mouth I will make your faithfulness known through all generations.
– Psalm 89:1, NIV

PRAYER: Heavenly Father, keep me focused on You and the light of Your truth and lead me in Your ways. Help me to remember to keep You first in my life and place You in front before any of my difficulties. Help me to bask in the light of Your love and trust in Your sovereign control over my life. Amen!

CALL TO ACTION: This week, try to practice staying focused on God's goodness rather than today's current difficulties.

FOR FURTHER ENCOURAGEMENT: Psalm 89:1, Psalm 43:3, 2 Samuel 22:29, Isaiah 42:16, and Psalm 91:1

Write here about a time when you struggled to let God lead you.

The heavens declare the glory of God; the skies

proclaim the work of his hands.
– Psalm 19:1, NIV

You are worthy, our Lord and God,
to receive glory and honor and power,
for you created all things,
and by your will they were created
and have their being.
–Revelation 4:11, NIV

Let heaven and earth praise him, the seas
and all that move in them,
– Psalm 69:34, NIV

Rainy Day Afternoon Tea

It's our devotions and teatime again, my friends. I'm so glad you're here today. I hope you brought your Bible to tea with you. There are always scriptures to look up and prayers to pray during our teatimes together.

We have had a lot of rain this week, and the sound of a thunderclap can be heard out my window while I'm setting up your tea. Don't you just love a good rainstorm? As far back as I can remember, I have loved to turn off the lights, light a few candles, and make rainstorms a celebration! So, let's celebrate together. I want to set a special tea table for you.

The centerpiece on our table is this porcelain French Damsel that belonged to my husband's grandmother. Her posture always makes me wonder what she is thinking, and I always picture her in a very formal garden, perhaps standing by a fountain. We will surround her with pink alstroemeria flowers that compliment her skirt and match the vintage pink embroidered linen napkins. You will enjoy your tea today in delicate hand-painted teacups from the 1800s that belonged to my great-grandmother. Do you feel special yet? You are!

Rainy weather calls for comfort food. Since blueberries are in season, I decided to bake an old-fashioned cream cheese blueberry buckle to go with our tea today. This recipe calls for a little lemon zest, and the flavor combination delights your taste buds. I love this recipe so much that I will share it with you at the end of this chapter. The citrus notes of Harney & Sons Paris tea go so well with the blueberries and lemon zest in this recipe. I promise you will want more than one cup.

While you sip your tea and enjoy this fresh out-of-the-oven dessert, I want to share my heart with you. By now you have come to realize that every time we have tea, I always like to share a true story and remind you of God's faithfulness, using moments in our lives to draw each of us closer to Him. Recently I was asked why I share such intimate stories from my life. The answer is threefold: First, I think the most important thing we can do in life is to pass our faith on to the next generation. Sharing events from our lives and how God worked to grow our faith through those events is the greatest legacy we could ever pass along to our family.

Second is YOU! God has given me a heart to reach out to you and to nurture you in your faith walk. Just as Jesus taught by sharing stories in parables, I desire to share stories that show you how God sometimes reveals His ways to you through the events of your life. It is my hope that you will begin to look at your day-to-day events in a different way, and my heart's desire is that you would begin to see everything as a way to learn more about God and draw closer to Him.

Third is the Great Commission. In this small way, through my teatime stories, I share the message of God's salvation and sanctifying work in all of us.

So, having said that, pour yourself another cup of tea, my friend, and settle down near the window where you can watch the rain fall. I'm going to share a funny memory of my father with you. He was my stepfather, but he raised me from a small child, so to me, he was my dad. He was an unbeliever all his life, and I can remember repeatedly witnessing the plan of salvation to him. After years of telling him of God's plan of salvation, I was privileged to hear him pray and give his life to Christ, only a year before God took him home to Heaven. I hope that this particular memory of my father will speak to your heart about something we all struggle with.

Keep your heart
With all Vigilance

For from it

Flow The

Springs Of

Life

Proverbs 4:23
ESV

Wrestling Match
Devotion

Sometimes a sight or sound will suddenly elicit a very distinct memory of my father. Recently I saw an advertisement about a wrestling match to be aired on TV, and immediately I had memories of my father stretched out in his favorite recliner. His stocking feet would dangle over the footrest, and he would be snoring loudly over the sounds of the wrestling match. Most of the time he watched baseball or football, but sometimes it was wrestling, and almost always he would doze off, even during the loud noise of the action. As a young girl, it always intrigued me that he could sleep through that noise, but if my mom turned the sound off, he would immediately wake up. I know some of you are laughing right now because you have someone in your household who does the same!

I can remember that I was mortified by the whole wrestling scene. I couldn't understand why everyone cheered when the bell rang and they held up the hands of the winner. As for me, rather than rejoicing with the victor, I always felt sorry for the man on the bottom. My sympathy went out to the defeated one who had wrestled but gotten worn out. I sympathized with the one who had given it all he had but ended up on the bottom. I felt sorry for the one who had fought his opponent with all his strength but in the end was overcome during the wrestling and succumbed to defeat. It was always such a pitiful scene to me.

Recently I experienced my own wrestling match. The fight was taking place in the ring of my mind, and I was wrestling with a familiar and formidable opponent—my own thoughts. I knew that I couldn't give in to these negative thoughts that were fighting with my soul. If I did, I knew that I would end up pinned down and emotionally defeated. Have you experienced that? I'm sure you have. If we are honest, all of us have. When I am in a struggle like this, I always run to the Scriptures to find the strength I need to conquer my foe. That day, as I flipped through the concordance in my Bible to look up the word *wrestle*, I was reminded that I wasn't alone in this fight.

In Psalm 13:2, David admitted to this same struggle. In the midst of his personal wrestling match, he cried out to God, *"How long must I wrestle with my thoughts and day after day have sorrow in my heart"* (NIV).

> *But I have trusted in thy mercy;*
>
> *my heart shall rejoice in thy salvation.*
>
> *I will sing unto the Lord,*
>
> *because he hath dealt bountifully with me.*
>
> *— Psalm 13:5-6, KJV*

From David's words, we get the idea that his fight was a long one. I imagine that he was fighting with the enemy of constant "what if" thoughts. "What if Saul finds me?" and "What if my enemy triumphs over me?" In verse 4, he shows that he was wrestling with the thought of his foes laughing and rejoicing over his failure. David was in a fight for sure, but his biggest battle wasn't with Saul; it was with his own thoughts and fears. He needed to find the strength to wrestle through to victory by remembering what God said about him, and he finally did just that.

In verse 5, David rallied to victory by reminding himself, *"But I trust in your unfailing love; my heart rejoices in your salvation"* (NIV). David wasn't down for the count. He picked himself up by focusing on God's goodness, pinning the negative thoughts down, and redirecting his thoughts Godward. By him doing that, his strength returned, and the wrestling stopped. David defeated his foe, and we can too!

In Philippians 4:8 (KJV), we are given the tools we need to win the wrestling match that goes on in our minds. God's Word tells us, *"whatsoever things are true, whatsoever things are honest, whatsoever things are just, whatsoever things are pure, whatsoever things are lovely, whatsoever things are of a good report; if there be any virtue, and if there be any praise, think on these things."* God is telling us that focusing our thoughts on these things gives us the power to push away the opponent of negative thinking and become the victors!

I've determined there will no mental wrestling matches for me, but if there is one, I will not be the one pinned to the ground. I will defeat those negative thoughts and have victory in Jesus through His mighty Word!

Rejoicing in hope; patient in tribulation; continuing instant in prayer;
– Romans 12:12, KJV

PRAYER: Oh Lord, forgive me for allowing the enemy to wreak havoc on my mind. Thank You that You have given me Your powerful Word to overcome the enemy. I pray that Your Holy Spirit enables me to dwell on that which is true. Jesus, YOU are the truth! I trust You to bring me to total victory over the wrestling match in my mind. Amen!

CALL TO ACTION: Memorize Philippians 4:8. Make a list of things that fit each category, "true," "just," "honest," etc., so that the next time you wrestle with the enemy of negative or fearful thinking, you can recall the truth of God's Word and gain the victory!

FOR FURTHER ENCOURAGEMENT: John 10:10, Romans 12:2, Proverbs 4:3, and Ephesians 4:23

Write here about a time when you wrestled with negative thoughts and were victorious.

My Homemade Blueberry Buckle

Ingredients for batter: 1/2 cup white sugar, 1/4 cup brown sugar, 1/4 cup butter, 1 egg, 2 teaspoons lemon zest, 1 & 1/2 cups flour (I used self-rising) 2 teaspoons baking powder, 1/2 teaspoon salt, 3/4 cup milk, 6 oz cream cheese, 1 or 2 cups blueberries, depending on your preference.

Ingredients for topping: 1/4 cup butter, 1/4 cup brown sugar, 1/4 cup white sugar, 1/3 cup flour, 1/2 teaspoon cinnamon

Instructions: Preheat oven to 350 degrees F (177 C for our UK friends). In a large bowl, mix the cream, sugar, butter, egg, and lemon zest until light and fluffy. In a separate bowl, combine flour, baking powder, and salt. Add to sugar mixture, alternating with milk, and beat just until combined. Dust the blueberries with a little flour and then fold them into the batter. Spread batter in a lightly-greased pan. Dot the cream cheese all over the top of the batter. Now, combine the topping ingredients until crumbly and sprinkle over top of batter. Bake 40 minutes or until top is nicely browned.

Enjoy your homemade blueberry buckle with a hot cup of your favorite tea.

Finally, brothers and sisters, whatever is true, whatever is noble, whatever is right, whatever is pure, whatever is lovely, whatever is admirable–if anything is excellent or praiseworthy–think about such things.
– Philippians 4:8, NIV

To be made new in the attitude of your minds; and to put on the new self, created to be like God in true righteousness and holiness.
– Ephesians 4:23-24, NIV

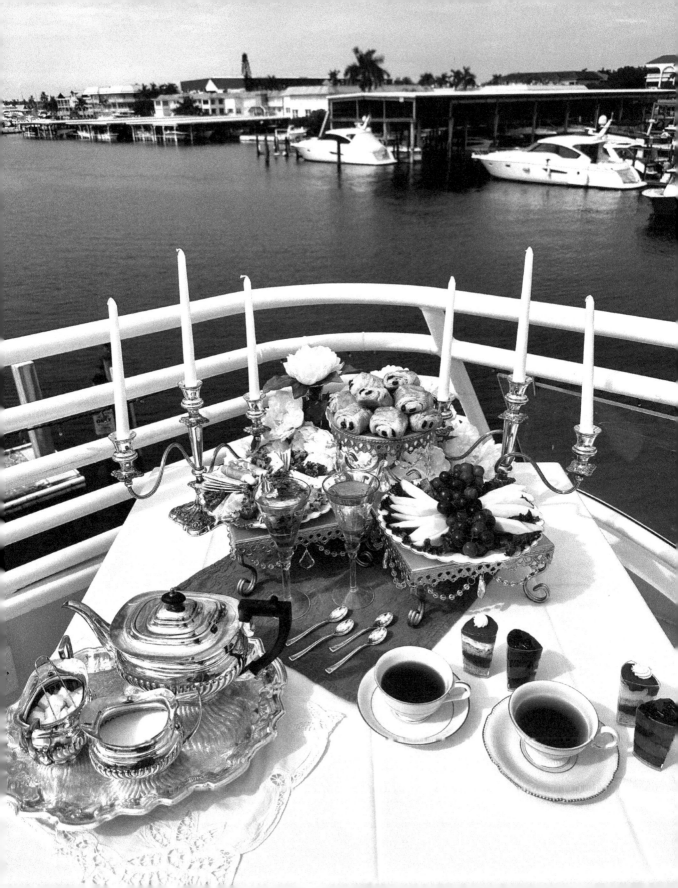

Silver Service Tea Aboard the Naples Princess

Clear blue skies, salty bay breezes, and sparkling gulf waters usher you into the delights of today's teatime brunch on board the Naples Princess Cruise Ship. As we approach this beautiful ship and board the lower deck, we hear music playing on the sound system and immediately notice the high gloss cherry wood and beautiful reflective ceilings in the dining area.

The comfort of rich leather chairs in lovely air-conditioned rooms with large viewing windows lets us know this will be a delightful and luxurious experience. It's easy to see why the Naples Princess is known for their day cruises through Naples Bay and into the Gulf of Mexico. Their breathtaking Florida sunset cruises are a pure delight. Quite often schools of dolphins will be seen playing in the ship's wake, delighting everyone on board as the ship slowly cruises the bay.

This morning you might want to don your sun hat and put on your sunglasses as we are ushered by the captain up two flights of stairs to the top sun deck of this 105 foot air-conditioned luxury yacht. Although they offer meals during their dinner cruise, the captain was kind enough to allow me to bring my own afternoon tea service for our teatime devotions today.

The sun is brilliant overhead this morning. I wanted you to experience an elegant treat today, so I boarded in advance of your arrival and set up an antique silver service tea set and silver candelabras that were given to me, and brought delicious culinary delights I prepared for your enjoyment. I knew the silver would glisten in the sunlight and set an ambiance that would make you feel as special as you are in the sight of God.

As we stand gazing over the bow of the boat into the sparkling gulf waters, we know this will be a teatime devotion to remember. Find your favorite viewing spot and let me pour you a cup of tea in these ivory-colored bone china teacups. You will enjoy chocolate chip croissants for starters with your first cup of English Breakfast tea this morning. After enjoying the warmth of the sun for a while, you might want to refresh your palate with these cool mango slices and grapes that I arranged to resemble a butterfly on a bed of greens. Our savories today are prosciutto wrapped mozzarella cheese rolls and slices of citrus-ginger turkey breast, which share a platter with La Panzanella artisan crackers.

I love these azure blue stemware glasses that make our ice water match the brilliant blue sky overhead as we settle in to enjoy our teatime devotions today.

Living so close to the water, our family has always enjoyed boating and fishing. My son, in particular, loves boating, fishing, and diving. He is skilled in many areas and is currently refurbishing his father's fishing boat from bow to stern. As my thoughts go to my son, I want to share a story of an experience he had that impacted our entire family. Find a comfortable place to sit where you can see the dolphins play while you sip your tea and listen as I share how powerful God's protection is over His children.

Sudden Protection

Devotions

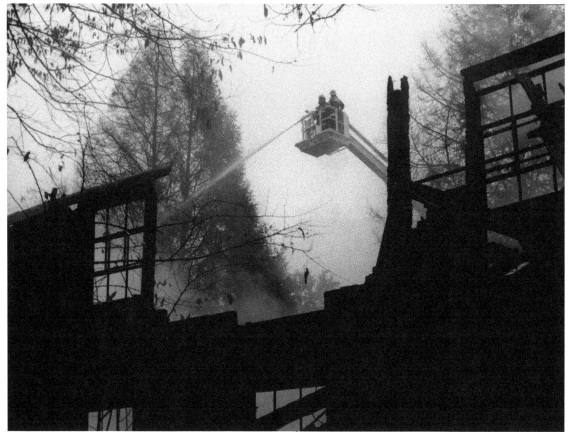

Photo Lee University, 1993

It was November 1993. The piercing sound of my phone ringing by my bedside at 3:00 a.m. startled me out of a deep sleep. With my heart racing, I reached over to pick up the receiver and stretched the coiled cord of our old rotary dial phone, bringing it to my ear. With our 18-year-old son away at his first semester of college, I tried not to panic and hoped that it was just a wrong number.

My son's shaken voice on the other end of the line confirmed the maternal alarm I felt inside. "Mom," he said, "I'm standing outside in the cold watching my dorm burn down." My husband, sound asleep next to me, shot up with a flash, when I poked his arm and said, "Get up! Brian needs us!" Although our son had

tried to reassure us, a mother's heart can hear what's not being said, so I knew we needed to start driving from Florida to Lee College in Cleveland, Tennessee, immediately.

Our two daughters were asleep at the other end of the house and had no idea what was going on. I tiptoed into their room and wakened them with a gentle touch. Hiding my alarm, as only a mother can, I gently announced, "How would you girls like to get dressed and go see your brother?" Those girls love their big brother and had missed him since he had left for college, so they were up in a flash without asking any questions or realizing what time it was. Moving uncharacteristically fast for that hour of the morning, I had all four of us packed and out the door in moments.

It was pitch dark when we pulled out of our driveway and hit the interstate. The girls, still not knowing what had happened and just happy that they were going to see their brother, fell asleep in the back seat of the car.

Most families didn't have cellphones in those days, so the ensuing 13-hour drive was without contact with our son. We had no idea how he was or what was taking place on that campus. The long drive in the dark was the perfect cooking pot for fear and worry. To win the battle going on in my mind, I spent the ride focusing on the things I knew to be true. I knew that God was faithful. I knew that He had a plan for our son's life. I knew that Brian had given his life to Christ and had grown up knowing how to trust God. Now, our son was experiencing something that would stretch his faith.

Upon arrival at the campus, we let out a gasp as we passed the still-smoldering pile of wood and ashes which hours earlier had housed our sleeping son and 76 other boys. All the parents, along with the students who had escaped the fire, were ushered into the chapel. Lots of tears, hugs, and shouts of "Praise the Lord, my son is alive" could be heard as the college president addressed the anxious group.

I will never forget his words: "We had a miracle occur in our midst … . We had a fire, which, but for the miraculous grace of God, would have left us with body bags all the way out to the street. I offer my gratitude and praise to the protective hand of God Almighty."

Still in a daze at hearing these words, the details began to emerge, and the magnitude of what had just happened became clear. The dorm was a two-story wooden structure with a brick veneer built in the 1930s. It had 76 beds and was at full capacity at the time of the fire. All the boys in the dorm were either asleep or up studying when they were suddenly alerted by shouts and the horrifying sight and sound of flames.

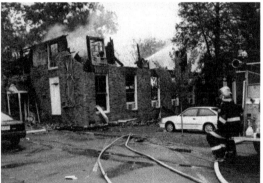

Photo Lee University, 1993

Photo by Cleveland Daily Banner, 1993

161

Photo Lee University, 1993

As our son opened his dorm door to try to escape, a wall of flames rushed in and wrapped around him, singeing his eyebrows and eyelashes and arm hairs before he was able to shut the door. He made his way to the window, knowing that it was his only means of escape, only to discover that he couldn't open it because it had been winterized with plexiglass. He tried to punch out the window, but the plexiglass wouldn't break. With adrenaline-fueled strength, he began punching at the plywood supporting the window AC and finally made an opening just big enough for him and his roommate to crawl through and get out. As the flames shot up to the sky, some of the students had to hurl themselves out of their second-story windows to save their lives.

The fire became so intense so quickly that the entire building was completely consumed in only four and a half minutes. The fire marshal later said it hadn't burned like a normal fire. It had the intensity of an explosion, and yet, every single boy had escaped alive. An escape from a fire that intense in only four minutes was nothing short of miraculous! But how? How was that miracle possible?

With sirens blaring and flames shooting high into the night sky, the boys huddled outside in the cold and paramedics tended to them. They were all alive and accounted for. There were some broken bones, and a few had to be airlifted to the hospital with burns. All of them were in a state of shock, as they began relaying the details of their horrifying escape stories to each other and the firefighters and paramedics.

One student from the second floor said his room was consumed with smoke when he was suddenly awakened by a man in a red cap telling him there was a fire and assisting him out the window. He didn't know who the guy was or how he got into the room because he slept with the door locked. One by one, other students, most of them from the second floor, also began reporting having seen a man in a red cap appear in their room, wake them up, and tell them to get out, sometimes assisting them in the escape. The same man in the same red cap appeared in different rooms simultaneously, and all in less than 4 minutes. It was a miracle!

My son is alive today because of a miracle. He and every student in that dorm fire will tell you they know without a doubt the man in the red cap was an angel sent from God to save their lives. Every parent who witnessed the aftermath of that fire and listened to the heart of their son describe the experience, gives glory to God for suddenly and miraculously sending His protective power. It is a life experience that taught me this: Where there is the possibility of sudden destruction, the hand of God provides sudden protection!

With the world as it is now, I feel like we need to pause a moment and read that again. **Where there is the possibility of sudden destruction, the hand of God provides sudden protection!** How can I make a statement like that? Because there are so many places in God's Holy Word revealing that He is with us at all times and will never leave us.

"When you pass through the waters, I will be with you; and when you pass through the rivers, they will not sweep over you. When you walk through the fire you will not be burned; the flames will not set you ablaze" (Isaiah 43:2, NIV).

My son, along with the other boys in that dorm, grew up learning to have faith in God, but that night they personally experienced God's faithfulness and the truth of God's protective power over their lives. Their experience reminds me of some young men in the Bible who also suddenly found themselves in a fiery situation.

Israel was under the reign of Nebuchadnezzar when Daniel and his friends, Shadrach, Meshach, and Abednego, were brought into the king's service. We are told that they were strong, healthy, young men who loved God, but when the king erected a statue in his own image and ordered everyone to bow before it, the boys refused. They knew what the consequences might be. The king's edict read: *"Whoever does not fall down and worship will immediately be thrown into a blazing furnace"* (Daniel 3:6, NIV). Still, being young men of faith and integrity, they could only worship Jehovah, the one true God.

Infuriated, the king had them brought before him to question their decision and remind them of the fiery consequences. Knowing what fate awaited them, they maintained full confidence in God's protective power and bravely answered, *"If it be so, our God whom we serve is able to deliver us from the burning fiery furnace, and He will deliver us out of thine hand, O king"* (Daniel 3:17, KJV).

We all know the story. The king went into a rage, ordered the fire to be heated seven times hotter than normal, and then had Shadrach, Meshach, and Abednego bound and thrown into the midst of that burning furnace. These young, healthy, wise, and strong young men suddenly found themselves surrounded by fire and facing destruction … unless the God they had put their trust in intervened. And He did! God displayed His protective power for Shadrach, Meshach, and Abednego, even as He did for my son and the other young men in their dorm fire.

"Then Nebuchadnezzar the king was astonished and rose up in haste and said, did we not cast three men bound into the midst of the fire? Lo, I see four men loose, walking in the midst of the fire, and they are not hurt; and the form of the fourth is like the Son of God. … Blessed be the God of Shadrach, Meshach, and Abednego, who hath sent His angel, and delivered His servants that trusted in Him" (Daniel 3:25, KJV).

Both of these stories of God rescuing His children are amazing, but the most important rescue story of all is when Jesus Christ rescued you and me from our sins. His love for us is all-encompassing, and His mercy is for all who call upon Him. *"For it is by grace you have been saved, through faith—and this is not from yourselves, it is the gift of God—not by works, so that no one can boast"* (Ephesians 2:8-9, NIV). *"For everyone who calls on the name of the Lord will be saved"* (Romans 10:13, ESV).

Do you wonder about the fourth man in the fire? His name is Immanuel, and that name literally means "God with us." We can take comfort in knowing that no matter the situation, our God is with us. We may not be able to escape all sorrows and difficulties in this life, and sometimes we may find ourselves in a fiery trial, but we are never there alone. God is with us. He will make a way for us to know His presence and fully trust Him.

"Whoever dwells in the shelter of the Most High will rest in the shadow of the Almighty. I will say of the Lord, He is my refuge and my fortress, my God, in whom I trust" (Psalm 91:1-2, NIV).

"You are my hiding place; you will protect me from trouble and surround me with songs of deliverance" (Psalm 32:7, NIV).

*You may be wondering where my son is today and what he has to say about his experience. Here is a YouTube link where you can hear Brian speaking and sharing his heart about the fire and what God showed him through it all. I hope you are blessed by his words.

PRAYER: Heavenly Father, there is so much potential for danger in this world. Help me to keep my eyes on You, and help me to remember Your great love for me. Thank You that You promise to cover me with Your hand of protection as I put my faith and my trust in You. Amen!

CALL TO ACTION: When facing the potential for danger in this world, be honest with yourself about your uneasiness. If something unexpected does occur, remember Immanuel. God is with you!

FOR FURTHER ENCOURAGEMENT: 2 Samuel 22:2-3, Psalm 91, Proverbs 3:25-36, Daniel 6:27, Psalm 34:4, Psalm 34:7, 2 Corinthians 4:8-9, and Psalm 56:3

Write here something about a time when God protected your family.

In
quietness
and trust
is
your
strength

Isaiah 30:15

The Lord is my rock, my fortress
and my deliverer;
– 2 Samuel 22:2, NIV

When I am afraid,
I put my trust in you.
– Psalm 56:3, NIV

The angel of the Lord encampeth
round about them that fear him,
and delivereth them.
– Psalm 34:7, KJV

Tea, Blossoms, and Daydreams

Today, as teatime friends tend to do, I invite you to share in one of my daydreams while we have tea. This time we aren't going to travel any further than my front yard, and you only need to bring a little imagination as we carry our tea tray outside. There is a little corner in my yard that I dream of filling with flowers. Since my mother loved roses and she grew them by the dozens, roses would be my preference. I have visions of those lush gardens of Europe, laden with roses that seem to climb to the sky. But, alas, here in the hot, humid South, roses struggle to thrive.

My family knows I often use the term "think prayers" to describe the times we aren't down on our knees in deep intercessory prayer. Instead, we think a prayer thought directed to God. Since God knows the thoughts and intents of our hearts, I know He hears our "think prayers" too. On the day of this lovely afternoon tea that I'm sharing with you, God answered one of my "think prayers," to have flowers in this corner for teatime.

I received a phone call from a florist who had several arrangements of roses left over from an event which he allowed me to repurpose. When he has those extra flowers, I always deliver them to people who need to know someone cares. A few flowers, a big hug, and some prayer time always lifts their spirits. I never know in advance when I might receive extra flowers or to whom they should be delivered, but God always shows me clearly who to bless.

Before delivering the flowers to others today, I decided to set a rose-themed tea for you to enjoy. For today's afternoon tea, we are going to be immersed in huge old-fashioned fuchsia roses and pink peonies surrounding us with their beauty and fragrance as we chat and have our devotions. Most of us love the scent of a rose. Did you know that it takes over ten thousand freshly-picked roses to produce one tiny 5 ml bottle of pure rose oil? I love drying organic rose petals to garnish my petite fours or adding crumbled rose petals to sugar for teatime. Another lovely thing to do with roses during afternoon tea is to tuck a single bud in the fold of a napkin or tie a handful to the back of each chair with some ribbon.

With all these roses we have today, I've prepared a very simple and refreshing alfresco tea for you, using bone china dishes that mirror our rose theme. The top tier of our server is filled with delightfully sweet French madeleines that are as light as a cloud. They are nestled beside a few lightly-browned and crunchy pecan sandies. I have also placed a few slices of fresh oranges and chilled grapes on the bottom tier to nibble on with our cookies. The real treat is these pastel petite fours I made for you, decorated with edible rice paper in rose bouquet patterns. Everyone loves these. Our tea selection today is Harney & Sons Paris tea served from a rose chintz pattern teapot. The subtle bergamot and light citrus notes of this tea are so refreshing as we sit outside sipping from these beautiful, bright rose teacups.

As we enjoy our afternoon tea among the flowers, we can hear the mockingbirds sing and sense the presence of the Lord with us. It's a good time to sit back and relax. As you sip your tea, I'm going to share a story that reminds us of God's never-ending love.

Offshore Slumber
Devotion

It was an overcast rainy day, the kind of day that brings out a melancholy feeling in most of us. I wandered around the house looking for something to lift me from the moodiness that was quickly engulfing me. My eyes were drawn to a tattered box that contained old family photos. For years I had intentions of gathering them into an album, but they continued to live in that box and only see the light of day when the mood struck me. This was one of those days.

As I curled up on the sofa with piles of photos on my lap, carefully separating each one, I became intrigued with an old black and white copy. It showed a little girl who appeared to be sound asleep, floating all alone in the ocean on a round rubber raft. The delicate photo was frayed, and the years had caused it to fade, but I knew that it had a story to tell. Turning it over, I saw my mother's name on the back. Curiosity got the best of me, so I called her to get the details of the story.

In the 1940s, when my mother was a little girl of about five, she was at the beach with her family. The warmth of the sun made the tiny little girl sleepy, so she curled up in an inner tube on the sand to take a nap. Before anyone noticed, the tide picked up the raft and carried the sleeping girl quite a way offshore. Sound asleep and unaware of any danger, she floated with the tide, ending up in deep water. Finally, someone in the group noticed and called a Coastguard vessel to tow her back to safety.

As I stared at that picture, it occurred to me that if she had slipped off the raft in her sleep or suddenly awakened and decided to hop off, thinking she was in the shallows, she most certainly would have drowned. Imagining all of the possibilities of that scenario, I marveled at how she could be completely asleep and unaware of the danger she was in.

While I was pondering the story, God used it to reveal a truth to me, as He often does when I am still and quiet enough to hear His voice. I realized that sometimes our lives can parallel my mother's raft experience. We can be going our merry way, enjoying all the blessings that God has placed in our lives, while we float along in the current of life in a kind of slumber, unaware of the danger our actions may be taking us into.

> *The Lord himself goes before you and will be with you;*
> *he will never leave you nor forsake you.*
> *Do not be afraid;*
> *do not be discouraged.*
> *—Deuteronomy 31:8,* NIV

While we are in this place of slumber, we can become completely lost in the comfort of our moment. In this state, it's easy to be unaware that we are floating to a place that is distant from safety, and possibly even distant from those who love us. At times like these, we need godly friends and spiritual mentors to grab our life's raft and tow us back to the shore of safety. I have to be honest and say that when I'm at the beach, I'm afraid to float out where the water might be over my head.

Recently I was at the beach with my adult daughter, and she laughed when she saw me hop off of my inner tube occasionally, checking to be sure I could still touch the bottom. There is no way you would ever find me falling asleep in a raft and floating into the deep waters as my mother did. However, I have experienced a kind of slumber in my spiritual walk, and I know that God has awakened me to bring me back closer to Him. He does this for all of us. Sometimes this rescue comes from the gentle nudging of His Spirit within our hearts, and at other times it comes from outside help in the form of family or godly friends. God knows when He needs to send someone to grab your life's raft and tow you back to shore. We can be confident that God loves us, and He will not allow us to stay in a state of spiritual slumber or float away from His protection. In His love, He reaches out to bring us back.

As I tucked the photo back in the box, I bowed my head in prayer and thanked God that through this little story from my mother's childhood, He had reminded me to stay awake and stay aware of His love and His boundaries that protect me. He reminded me, as He reminds all of us, that the hour is late and we need to guard ourselves against spiritual sleepiness.

Dear teatime friends, the Savior of your soul is holding on to the lines of your raft. Don't fear! You can't float too far away from His love. Listen to His promise in Deuteronomy 31:8 (NIV): *"The Lord Himself goes before you and will be with you; He will never leave you or forsake you."* Again, in Isaiah 41:13 (NIV), God comforts us with the words: *"For I am the Lord your God who takes hold of your right hand and says to you, Do not fear; I will help you."* If you feel distant from God, remember that our Savior's unconditional love for you will hold onto your line and bring you nearer to Him.

If you find yourself spiritually sleepy and beginning to drift away from the shore of God's perfect will for your life, cry out to Him. You can be confident that He will rescue you and bring you back to the safety of His presence. Just as swimmers are encouraged never to swim alone, let me encourage you to find someone to swim the life of faith with. Together you can pray, read the Holy Scriptures, and seek the truth that God holds out for you, and your spiritual slumber will soon awaken.

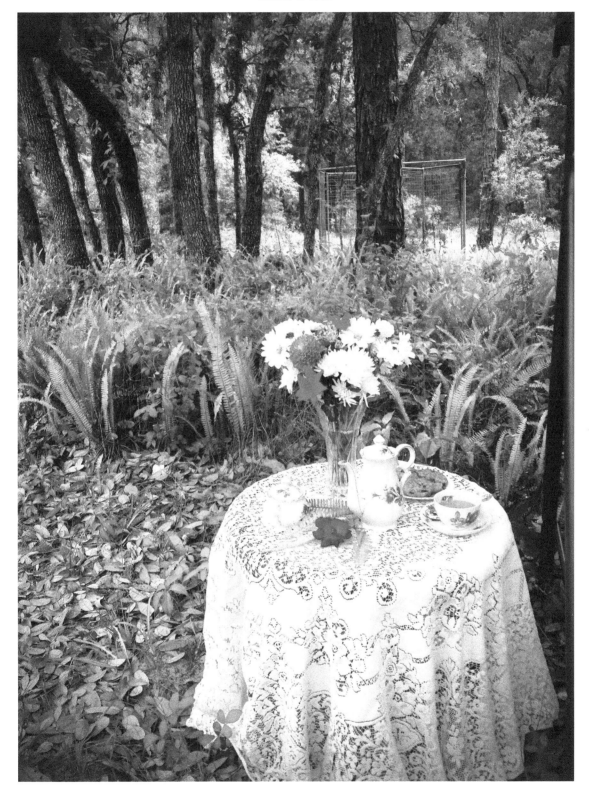

Draw near to God, and he will draw near to you. Cleanse your hands, you sinners, and purify your hearts, you double-minded.
– James 4:8, ESV

PRAYER: Dear Lord, Sometimes I feel spiritually sleepy and don't spend the time with You that I should, but I know that You love me and will draw me close and never let me slip far away. I ask Your Holy Spirit to nudge me when I need to spend time in Your presence, read my Bible, and pray more. I long to stay close to You. Help me also to be aware of others that may be spiritually sleepy, and give me the compassion and the boldness to come alongside them and encourage them to swim the life of faith with me.

CALL TO ACTION: This week, try to wake up every morning asking the Lord to help you notice someone who seems to be drifting alone. Come alongside them and seek the Holy Spirit's guidance and wisdom for how to encourage them in their walk of faith.

FOR FURTHER ENCOURAGEMENT: Isaiah 26:3, Isaiah 44:10, Psalm 138:7, and Psalm 121:3

When you feel spiritually sluggish, write here what you do to renew your desire to draw close to God.

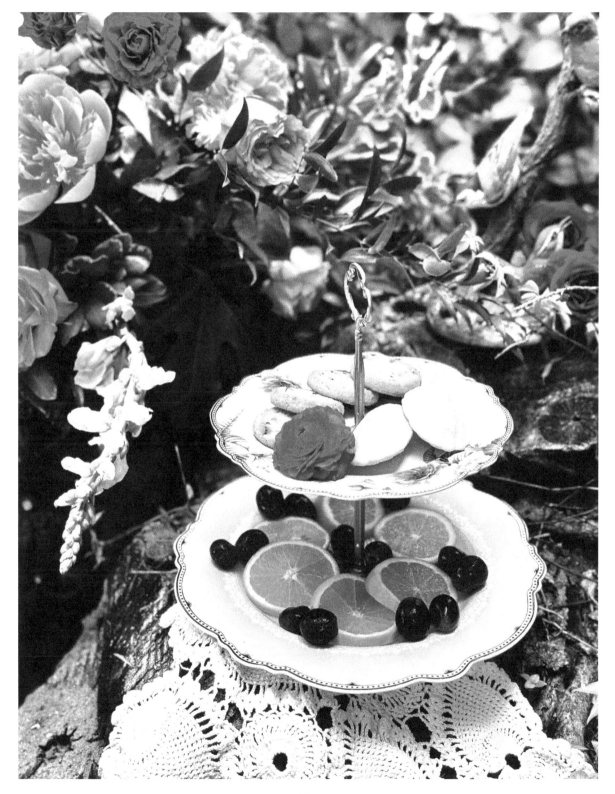

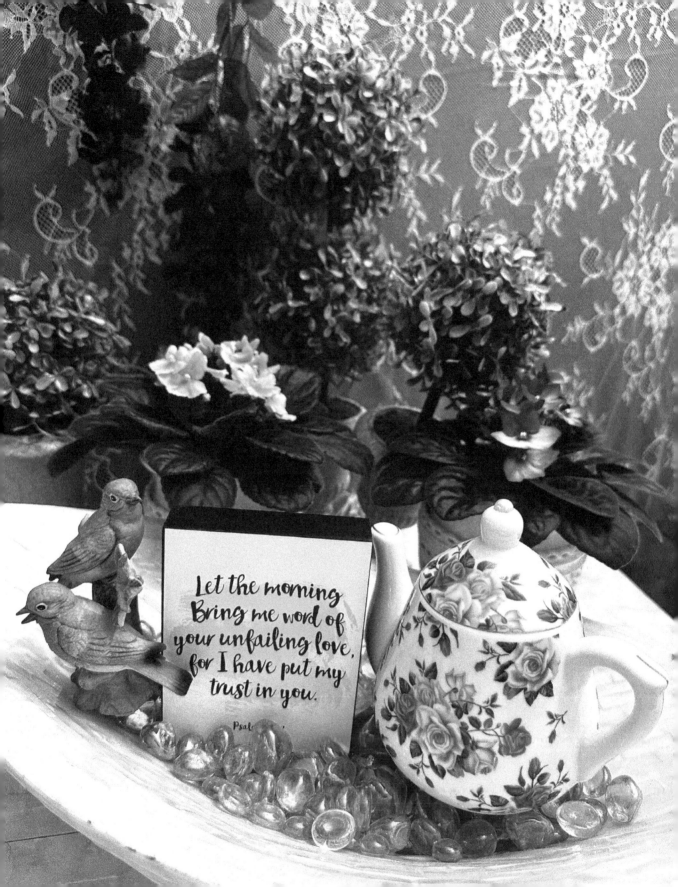

Let the morning
Bring me word of
your unfailing love,
for I have put my
trust in you.

Psal.

So we have come to know and to believe the love that God has for us. God is love, and whoever abides in love abides in God, and God abides in him.
–1 John 4:16, ESV

... then the Lord knows how to rescue the godly from trials, and to keep the unrighteous under punishment until the day of judgment ...
– 2 Peter 2:9, ESV

I will rescue those who love me.
I will protect those who trust in my name.
– Psalm 91:14, NLT

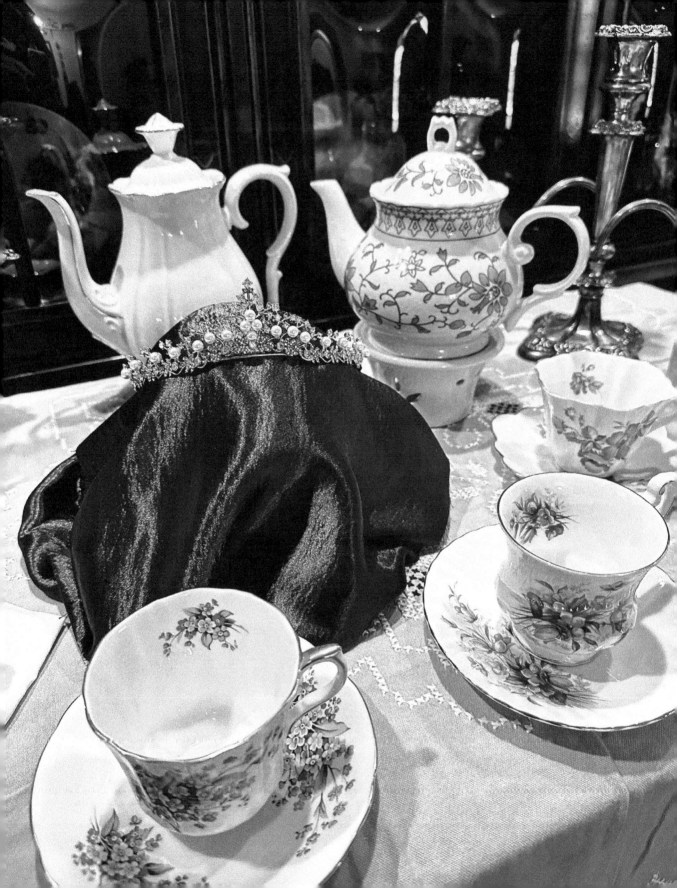

A Tiara for Teatime

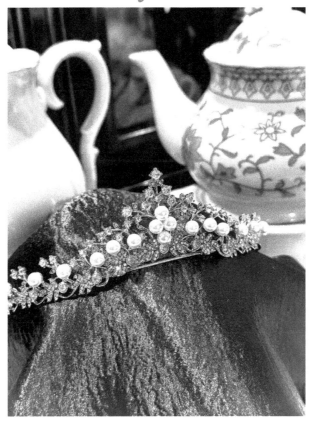

Have you ever wondered what it would feel like to be treated like royalty? This is your day! Wear something special and hold your head high because you are a child of the King of Kings and Lord of Lords, and He is with you every day and each time we gather for our teatime and devotions. As the music plays in the foyer, I welcome you to enter and enjoy this afternoon's dessert tea in your honor.

The ambiance of blue and white is fitting for our royal-themed tea today, so I covered the table with a vintage sky-blue hand-stitched linen tablecloth. There is something special about the feel of vintage linens and the knowledge that someone's hands did the stitching. I always try to imagine the life of the woman who lived years ago and spent hours hand stitching the linens we still enjoy today.

As you enter the room, I invite you to put on this tiara. It is resting on royal blue satin and just waiting for you. Secure your tiara and then choose the teacup you want to use today from this lovely variety of blue floral patterns, each with a royal pottery name. You can choose from the Royal Seagrave blue poppy pattern or Royal London's hand-painted forget-me-nots. There is also the Rosina Queens blue bouquet pattern or Royal Albert's beloved Dainty Dina Betty teacup.

When you hold one of these delicate vintage teacups, don't you just love to imagine who used it years ago? Just as I do with vintage linens, I always take a moment to ponder what the life of that woman was like, what she must have lived through during her era of history, and how many prayers she must have prayed while having tea. Oh, if teacups could talk!

After we enjoy some fellowship over our first cup of Earl Grey tea, the aroma of chocolate leads us to the dessert table where I have prepared for you Queen Elizabeth's favorite chocolate biscuit teacake, in keeping with the theme of our tea today. It is said that she loved this cake so much she would have a small slice of it every day with her tea, and if she traveled, the cake traveled with her. Hearing that, I just knew I needed to make it for you today. I obtained the recipe from her previous royal chef and include the recipe for your enjoyment in this chapter. It is a simple no-bake cake made with rich tea biscuits or cookies that are broken into pieces and mixed with melted chocolate, then pressed into a pan and placed in the refrigerator to set up. If you love chocolate, you will love this teacake! Between the filling and the icing, it uses 12 oz of solid dark chocolate, so it is quite rich. Let's each have a very small slice and settle back in our chair for another cup of tea.

You may have noticed that when you were seated at the table there was a scripture card in front of your place setting. I love doing this during afternoon tea to encourage each of us to engage in conversation about testimonies of God's faithfulness in our lives. When we realize that our sovereign Lord and Savior gave up everything out of His great love for us, what can we do but love Him back? When we know we are loved by the King of Kings and Lord of Lords, it doesn't take a crown to make us realize we are highly valued by our Creator. Sharing the truth of that knowledge with one another makes for uplifting and faith-building conversation.

Have you enjoyed wearing your tiara to tea today? I'm so glad. I think most of us at times have wondered how wearing a crown fools. Sit back and enjoy another cup of tea while I tell you why I often tell myself and all the women in my family to put on "the crown of flexibility." It's a crown that we all need to wear every day.

Queen Elizabeth's Chocolate Biscuit Cake - The Official Royal Recipe by Chef Darren McGrady

1/2 tsp butter, for greasing the pan
225g (8 oz) rich tea biscuits or sweet cookies
110g (4 oz) unsalted butter, softened
110g (4 oz) granulated sugar
110g (4 0z)dark chocolate
1 egg

Icing:
225g (8 oz) dark chocolate for coating
25g (1 oz) chocolate for decoration

Lightly grease a 15 cm x 6 cm cake ring with butter and lace on a tray on a sheet of baking paper.
Break each of the biscuits into almond-size pieces by hand and set aside.
In a large bowl, combine the butter and sugar until the mixture starts to lighten.
Melt dark chocolate and add to the butter mixture, stirring constantly.
Add egg and beat to combine.
Fold in the biscuit pieces until they are all coated with the chocolate mixture.
Spoon mixture into the prepared cake ring. Try to fill all of the gaps on the bottom of the ring because this will be the top, when it is unmolded.
Chill the cake in the refrigerator for at least 3 hours.
Meanwhile, melt the dark chocolate for coating in a double boiler, or saucepan on the stovetop over a low heat.
Slide the ring from the cake and turn it upside down onto a cake wire.
Pour melted chocolate over the cake and smooth the top and sides using a palette knife.
Allow the chocolate to set at room temperature.
Melt the remaining chocolate and use to decorate the top of the cake.

A Crown of Flexibility
Devotion

Adrenalin-fueled excitement gave me extraordinary energy to carry luggage out to the car to leave on a much-anticipated vacation the next morning. I had carefully planned every day of the trip, so I wasn't prepared for my husband's announcement that one of the employees had called in sick, requiring him to have to work, which meant we had to delay our vacation. As I sadly carried the luggage back into the house, I suppressed my disappointment and whispered to myself, "Put on your crown of flexibility, Sherri."

I remember another time I had to symbolically wear that "crown." I had spent weeks preparing for all of our children and grandchildren to stay with us over the holidays when the water heater burst and leaked all over the floor. As we made arrangements for everyone to shower in other locations, I once again told myself to put on that crown of flexibility and learn to be content whatever the circumstances.

Years ago, when we took our first trip to England, we rode a train through London. During the ride, the conductor announced there was a fire on the track ahead of us, which required everyone to disembark in an unfamiliar area late at night. That was a change that came with a bit of fear and required, not only being flexible and accepting an unexpected change, but also trusting that God was directing our steps. And He did. We were rescued by a wonderful Christian family that let us stay in their home and we have become great friends since that trip.

In the grand scheme of things, those experiences were just minor inconveniences, but many times in life we find ourselves in the midst of huge life-altering changes. When both of my daughters, who were very successful at what they did, had to make unexpected career changes, their entire lives had to suddenly adapt to the change. When the world was experiencing a global pandemic, all of us found ourselves forced into accepting changes that were not of our own doing. Sometimes our carefully planned lives are interrupted by an illness or caring for someone else close to us who is ill. How do we accept these changes? How do we handle circumstances out of our control?

The Bible is full of stories of men and women who show us how to trust God through sudden changes. In all of these, we can see that God either directed those changes or used circumstances to accomplish His purposes in the life of the individual—for their good and for His Kingdom.

185

Just imagine what a sudden change Peter went through. He was comfortable living the simple life of a fisherman. I'm sure he didn't plan a change in his life, but then along came Jesus, who called Peter to follow Him as a disciple. That simple fisherman made a huge life change, and in following Jesus, he was able to confess Jesus as *"the Christ, the Son of the living God"* (Matthew 16:16, ESV). From the life of Peter, we see that God knows where we need to be, and when, and that no purpose of His can be thwarted (see Job 42:2).

Moses is another example of needing to be flexible with unexpected change. He experienced massive change from living a wealthy life of luxury in Egypt, to that of a hard-working shepherd in Midian. That wasn't a change he expected, but God was leading Him and directing his every step. For 40 years Moses learned that He was not in control, but that God was, and during that time Moses learned the obedience needed to hear God's voice and lead His people out of slavery.

What about the change that Jonah experienced, living in Israel as a respected prophet one day and living in the belly of a whale the next, praying in a beautifully adorned temple one day and praying from the belly of the fish the next? He had rebelled against God's instructions to leave Israel and go to Nineveh to preach, so God directed Jonah's steps right into the

belly of the fish, to put him in a place that would bring him to repentance. As a prophet, Jonah loved God, but his heart wasn't obedient. He found himself in a change of circumstances that didn't look good, but it ended up for his good and the good of the people of Nineveh. Romans 8:28 comes to mind when I think of Jonah's story: *"And we know that for those who love God, all things work together for good, for those who are called according to His purpose"* (ESV).

If I could give the crown of flexibility to someone in the Bible, it would be Mary the mother of Jesus. Mary was living the simple, carefree life of a young single girl ... until the angel Gabriel told her she would become the virgin mother of the Savior of the world! God interrupted her plans that day, but it was a divine interruption. Submitting to the plan of God for her and for the world, mothering and raising our Savior, and then watching Him die on the cross ... none of that was originally in Mary's plans for her life. But she loved God. She trusted Him, and she trusted His Word.

Therefore, she submitted her plans to His will for her life. She earns the ultimate crown of flexibility!

We need to remember: Whenever God steps in and interrupts our plans, it's always for a greater purpose. *"For my thoughts are not your thoughts, neither are your ways my ways,"* declares the Lord. *"As the heavens are higher than the earth, so are my ways higher than your ways and my thoughts than your thoughts"* (Isaiah 55:8-10, NIV).

We shouldn't be anxious when plans change. Let's try to remember to ask God what His purpose is in the change. When our plans are changed, let's look for the unexpected blessing that could come from the change. We have to believe the Word of God which tells us that God is sovereign over our lives and that He establishes our steps. *"The heart of man plans his way, but the Lord establishes his steps"* (Proverbs 16:9, ESV). If you find yourself in a situation in which you need to wear your crown of flexibility, remember: even though circumstances change, God doesn't!

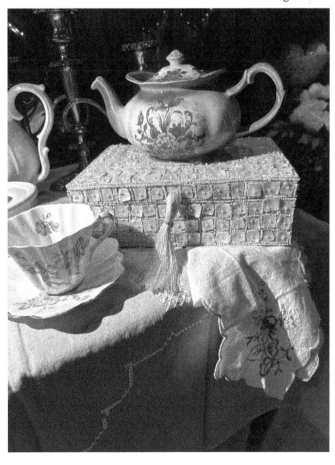

Not that I speak from need,
for I have learned to be content
in whatever circumstances I am.
– Philippians 4:11, NASB

PRAYER: Heavenly Father, forgive me when I forget that my life is from You and is in Your hands. Help me remember that You love me and that You direct my steps and have my ultimate good in Your purposes. If I get rattled when my plans are interrupted, please send Your Holy Spirit to remind me to patiently trust in Your perfect ways.

CALL TO ACTION: When you see that your plans are being changed, ask the Holy Spirit to help you have discernment and be spiritually sensitive to what God might be doing. Determine that you will be obedient to changes that God is putting in front of you and avoid the temptation to push for your way when you sense that the changes are from God.

FOR FURTHER ENCOURAGEMENT: Philippians 4:6-7, James 1:17, Psalm 34:8, Proverbs 16:9, and Isaiah 43:19

Write here about a time your plans were changed and you needed to wear the "crown of flexibility."

"The heart of man plans his way, but the Lord establishes his steps" Proverbs 16:9.

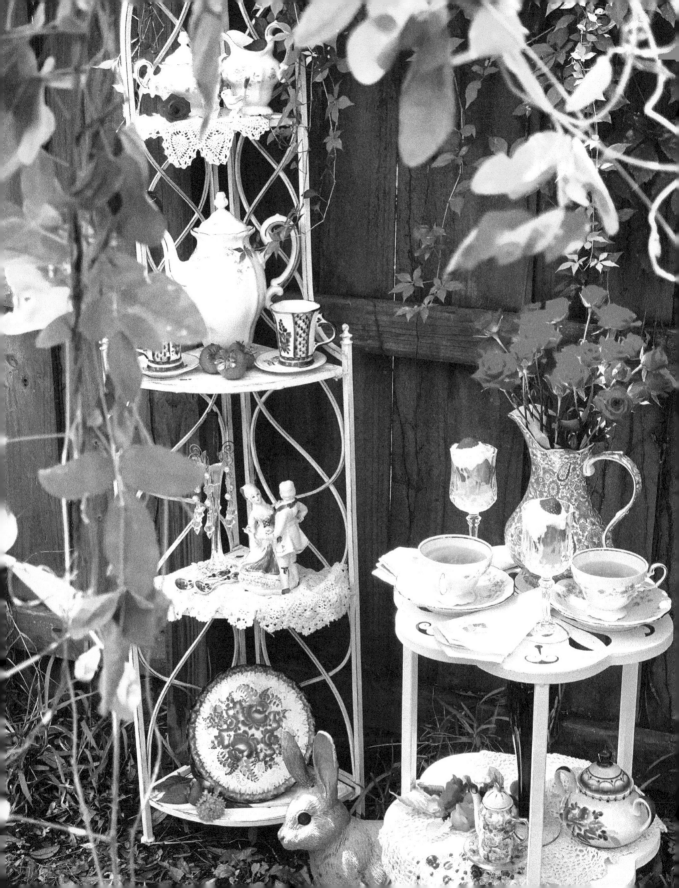

I know that you can do all things;
no purpose of yours can be thwarted.
–Job 42:2, NIV

For my thoughts are not your thoughts,
neither are your ways my ways,"
declares the Lord.
– Isaiah 55:8, NIV

"For I know the plans I have
for you," declares the Lord, "plans to
prosper you and not to harm you, plans
to give you hope and a future."
– Jeremiah 29:11, NIV

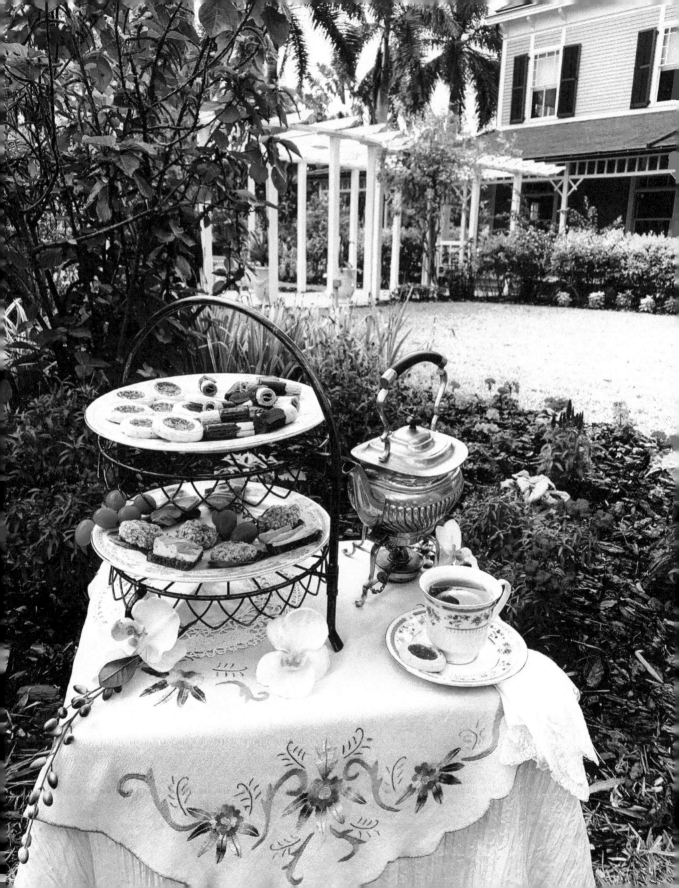

Tea at the Edison/Ford Winter Estates

In an area where bamboo grows tall and orchids drape in the trees alongside wispy Spanish moss, you are invited to an alfresco afternoon tea deep in South Florida at the home of famous inventor—Thomas Edison's winter estate.

Before we tour Edison's home and see his laboratory, let's set up our table in the grass just outside the veranda near this lovely flower garden. We will adorn the table with a vintage embroidered linen tablecloth, layered over golden yellow crushed satin skirting, that matches the yellow of the orchids growing from the trees. In keeping with the date of the home, I am serving your tea from this antique tilting teapot that was given to me by friends in my church. It is designed in the traditional Georgian style and sits atop a burner to keep the tea warm. It also has a lovely ebony handle, so you don't feel the heat when you pour. It's so interesting to tip a teapot on a hinge to pour tea instead of picking the teapot up.

Our savories today are reported to be some of Thomas Edison's favorite foods and are local to the area. Fresh avocado slices, salted and peppered, and served on pumpernickel toast are as lovely to look at as they are tasty. Crabs are easily pulled from the waterways behind the home, and Thomas Edison loved crab cakes, so I am serving you mini-crabcakes made with onion and parsley resting on a spinach bed. A few locally grown bright red lychee nut fruits are cool and refreshing after our savories.

The tea I'm serving today is Lady Grey, one of my favorites. I love the delicate bergamot and citrus notes in this tea, and it's great with a thin slice of lemon floating in your teacup. We will enjoy a few cookies and another cup of tea and then start our tour of Edison's home and laboratory.

Chocolate and fruit are always a great combination, so I brought hazelnut-filled Pirouettes dipped in chocolate, and almond shortbread cookies with an apricot raspberry filling for our dessert.

Edison's Laboratory

After all that food, we need to stretch, so let's take a stroll through a portion of this 20-acre park-like setting with its scenic river view. Edison used the property for an experimental garden growing 400 varieties of trees and shrubs collected from all over the world, some of them used in his inventions, like the goldenrod plant that produced the rubber he sent to Harvey Firestone, who used it for tires. As we walk, we are shaded by the abundant bamboo which he discovered could be used as a filament source in his lightbulbs. As we head back toward the house for a tour of the home, we pass a massive banyan tree whose aerial roots spread out 400 feet and is reported to be the largest banyan in the entire United States. Standing under this tree is a favorite photo spot for both locals and visitors.

There are nine historic buildings to visit, including Henry Ford's home, which is situated right next to Edison's. They were great friends and built summer homes next to each other. We will focus on Thomas Edison's home today. As we approach Edison's home, we enter through the wide wrap-around verandas that allow the French doors to be left open even during heavy subtropical rains. There is also a breezeway that connects the living room and entertaining area to a separate building that houses the kitchen and dining room. Edison disliked the smell of cooking, which is why he designed the house with these areas separated. You will love peeking in the window of the kitchen, where the original appliances and utensils are still standing. The home itself is exactly like Mrs. Edison left it. It's casual and cozy, with Early American wicker furniture and chintz coverings. The light fixtures are original and still have the original carbon filament bulbs in them, which, amazingly, have never burned out to this day. I stood for a long time enjoying the lace on the table, the silver on the hutch, and the beautiful lampshades in the living room. The home was never air-conditioned, but even in this South Florida heat, it remains comfortable due to the open breezeways and brilliant updraft Edison created in the building.

Entering Edison's research laboratory is mind-boggling! It's like a journey back in time. There is so much to see! Where do we start? His laboratory has been left intact and has all the test tubes, machinery, and equipment he used in his experiments still sitting in their same location on his many work benches. Some of his greatest inventions were developed right in this room, and we can see the process of each still laid out as it was when he was working on them. In this laboratory, we can see inventions spanning many fields, from battery power and electrical lighting to sound recording, chemistry, and botany.

Walking from his laboratory over to the museum, we can view the first phonograph, various light bulb designs, and some of the rubber Edison invented. His 1916 Model T, given to him by Henry Ford on his birthday, is also on display in the gallery. My favorite was the original 1878 talking doll that he invented, which had a tiny phonograph inside that played nursery rhymes. It has been an interesting visit.

As we leave the building and begin walking back to our tea table out in the garden, my heart is filled with thoughts I want to share with you. As wonderful as it is to visit places like this, we can't dwell here. Pour another cup of tea and let's talk about the difference between visiting and dwelling.

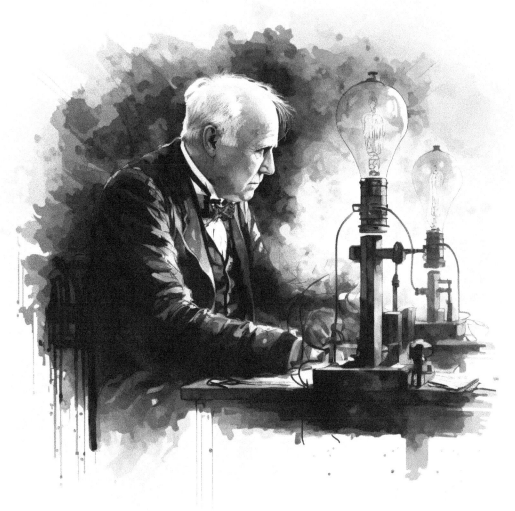

Adobe Stock Photo

Edison at his desk

Do We Visit or Dwell?
Devotion

There are many books on my bookshelf, but my favorites are the photo albums of places we have visited. One of my largest albums was created by my youngest daughter and has lots of beautiful embellishments on the cover and throughout the album. It is thick and heavy and truly a work of art. Turning the pages and looking at those photos can mentally transport me back to those places and almost make me feel as if I am there again.

We have visited various locations around the U.S., made visits to the homes of families living in other states, and even made one visit out of the country to England. At each of those locations, our hosts did everything they could to make us feel at home while we were there.

Our visit to England was wonderful. We made new friends who opened their homes to us and treated us as if we were family. They took us everywhere, made special meals for us, and invited us to join in on their family birthday celebration. It was a visit I will always remember, but it was just a visit. It was not the place where we dwell, and it was good to come home.

A long-awaited visit to an elderly aunt living at the mouth of the Chesapeake Bay was really special. Our children were young at the time, but we all remember her showing us how she pulled in crab traps from the waters behind her house and spread the cooked crabs out on newspaper on the table to eat with Old Bay Seasoning. Even at her age, she baked her famous butter pound cake while we were there and arranged a surprise paddle-boat day cruise on the Chesapeake Bay for us. It was a wonderful visit, but it was just a visit, and we came back home.

A visit to a cousin and retired military uncle living in Virginia near the State Capital was enjoyable and memorable. We were greeted with open arms and royal treatment. Special meals were cooked for us, family albums were shared with us, and the warmth and love of family was abundant. But it was just a visit. We don't dwell there, so we came back home.

Our yearly visit to my beloved aunt's cabin in Tennessee is always anticipated, and she goes to all manner of effort to make us feel at home in that special place. We love our visits there, but they are just visits. It's not where we dwell.

These memories of various visits came rushing to my mind while I was trying to read my Bible. I was reading from the English Standard Version in Psalm 91:1: *"He who dwells in the shelter of the Most High will abide in the shadow of the Almighty."* At first, when I started having all these memories of visits, I thought that my mind was wandering away from my Bible reading, but soon I realized that the Holy Spirit wanted me to ponder on the word *dwell*, and He was doing that by giving me a contrast to think about. Don't you just love it when God does that? Just as He had done in a previous chapter with the word *shadow* on the boardwalk, He was now drawing me to ponder the word *dwell*.

The natural question is: How? How can we *"dwell in the shelter of the Most High?"* We live here on Earth, so how can we obediently follow the instructions in God's Word to *dwell* in His shelter? We can't actually dwell with Him until He takes us home to be with Him, so what does He mean? Is there someone in the Bible who shows us how to be human and still "dwell" with God while here on Earth?

The person who comes to mind right away is the Psalmist David. Where did he dwell? As a young shepherd, he physically dwelled out in the fields with the sheep. Imagine him sitting on a rock, high up on a hill, living outside with his herd of sheep for months at a time. Historical records reveal that in biblical times, shepherds would dwell outside with their sheep day and night for about nine months out of the year. At that time in his life, David was physically dwelling with his sheep, but when we read his writings, it is apparent that his thought life dwelled on God. Maybe David's writings reveal to us the secret to "dwelling" in the secret place of the Most High.

The Bible calls David *"a man after [God's] own heart."* *"God testified concerning him: "I have found David the son of Jesse, a man after mine own heart"* (Acts 13:22, KJV). I'm sure there are many reasons for that, and only God can know all of those reasons, but I think one of them might have been that David's thoughts were godward. His thoughts "dwelled" toward God.

Throughout David's life, from shepherd to King, he poured out the thoughts of his heart toward God. I love how real David was. His writings reveal his emotional struggles and his doubts and fears. Even if he momentarily got in a difficult place mentally or emotionally, he always brought his thoughts back to that place of dwelling on God. He shows us how to *"dwell in the secret place of the Most High God."* At times his writings revealed that his thoughts would visit his struggles, but he would always refocus on dwelling on God's goodness, mercy, and loving kindness. In Psalm 77, David started out complaining about how distressed he was, but he quickly refocused those

distressed thoughts and decided to dwell on God and tell himself. *"I will remember the deeds of the Lord"...* *I will consider all your works"* (Psalm 77:11-12, NIV). David was giving himself a pep talk. He prayed, he worshipped, and then he was once again dwelling in the secret place.

Most of us will admit that there are times we feel as if we don't "dwell" as we should. There are times we get so busy we only have short visits with God. So how can we be more faithful and consistent in dwelling in the secret place of the Most High? We can start by asking the Holy Spirit to renew our minds and keep our thoughts fixed on Christ and His Word. It's helpful if we don't just visit the Word of God sporadically, but have regular times of reading His Word, dwelling in His presence, and letting Him talk to us. We are dwelling with Him when we read His Word.

Another way is what I call "think prayers." We can't always be down on our knees in deep intercessory prayer, but as we go about our moments each day, we can do as David did and have our thoughts godward. Think prayers are a wonderful way to "dwell" moment by moment with the Savior. A "think prayer" can be as simple as walking out to your mailbox and thinking, "Thank You, Lord, for eyes to see Your beautiful blue sky and ears to hear the sounds of the birds," or thinking "Forgive me, Lord" when something comes to mind that you need to give over to Him. We are dwelling with Him as we think on Him and talk to Him moment by moment throughout our day.

God promised that He would never leave us or forsake us, so He is ALWAYS dwelling with us. We only need to be mindful of Him and keep our thoughts toward Him, and He will enable us to dwell in the secret place of the Most High.

Come near to God
and He will come near to you.
– James 4:8, NIV

PRAYER: Heavenly Father, thank You for Your faithful promise to never leave me or forsake me. I know that You always dwell with me, but, Lord, I want to dwell upon You more faithfully. I ask that Your Holy Spirit quicken my mind to focus more on You and less on the distractions of this world. Enable me by the drawing power of Your Holy Spirit to desire more time dwelling in Your presence, reading Your Holy Word and talking to You in prayer. I trust You to work this good work in me to the praise of Your glory. Amen!

CALL TO ACTION: Enjoy more moments of allowing your thought life to focus on the things of God as David did. Try to be aware of how many times you just quickly visit the presence of the Lord. Then make a determination to set aside more time to linger with Him in prayer and Bible reading.

FOR FURTHER ENCOURAGEMENT: James 4:8, Jeremiah 29:13, Matthew 4:4, Psalm 46:10, and Psalm 1:1-2

Write here what you do that helps you focus on dwelling in the presence of the Lord.

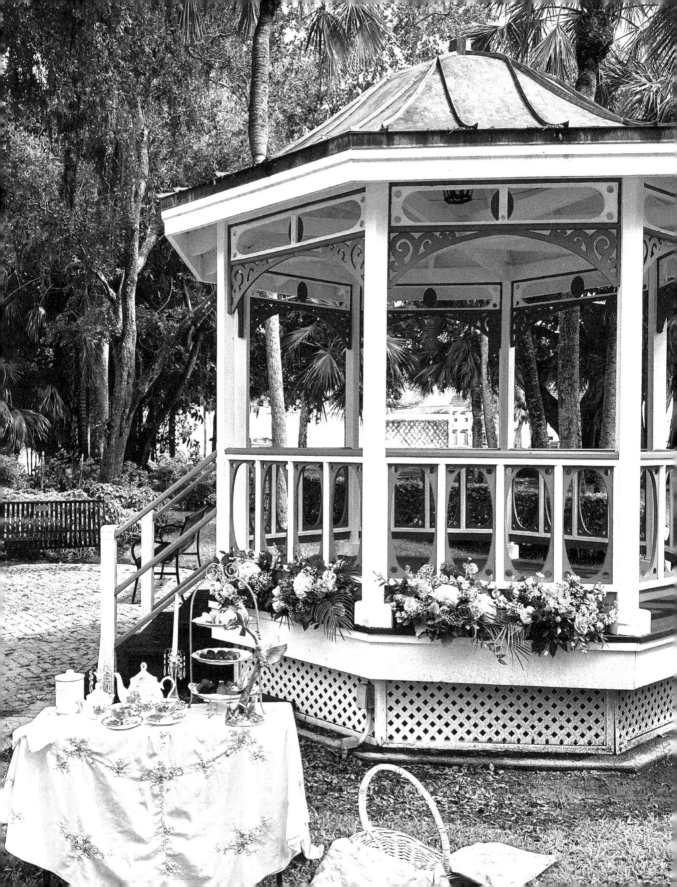

*He who dwells in the shelter of the Most High
will abide in the shadow of the Almighty.*
– Psalm 91:1, ESV

*And without faith it is impossible to please him, for
whoever would draw near to God must believe that
he exists and that he rewards those who seek him.*
– Hebrews 11:6, ESV

*Let the word of Christ dwell in you richly, teaching
and admonishing one another in all wisdom,
singing psalms and hymns and spiritual songs, with
thankfulness in your hearts to God.*
– Colossians 3:16, ESV

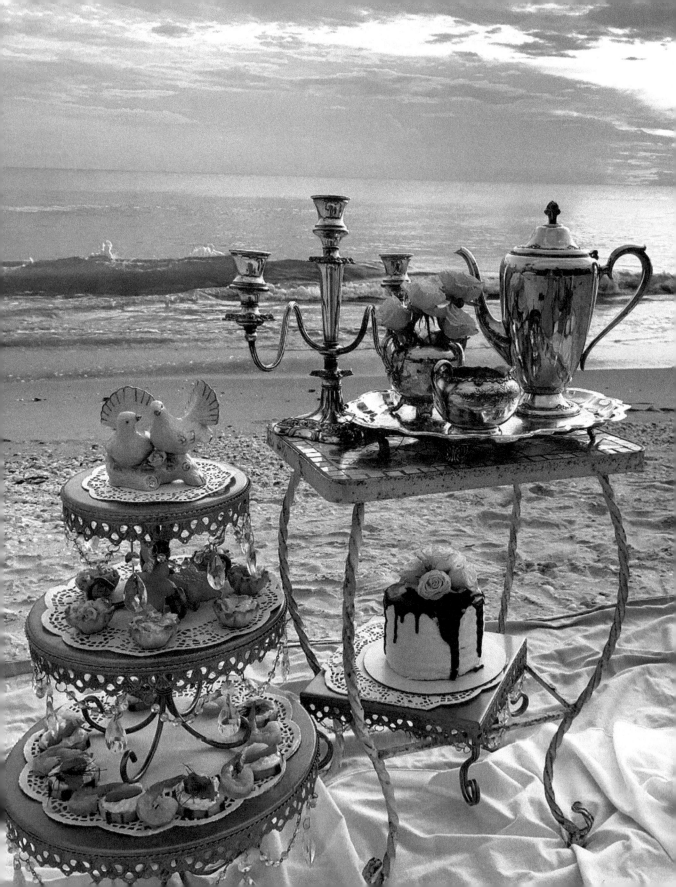

Sunset Tea and Wedding Cake on the Beach

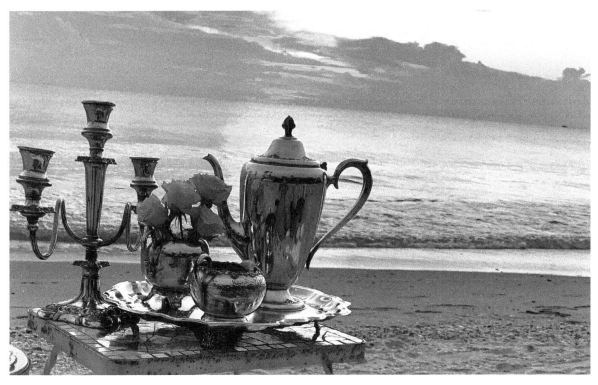

here can I take you for our last teatime chapter that would thrill your soul and leave a lasting impression on your heart? It didn't take long pondering that question before I knew I had to treat you to a spectacular sunset tea on the beach. But not just any sunset tea. We are going to take a bridal cake with us and celebrate the anticipation of a wedding reunion.

As we approach the beach, we roll down the car windows to breath in the rejuvenating smell of fresh salty air and smile at the sound of gentle waves crashing on the shoreline. There aren't many people at our chosen location, and the sun hasn't set yet, so we have plenty of time to find a quiet spot on the beach to set up our evening tea.

We brought everything we need to celebrate together in a beautiful fashion. First, let's spread yards of beige fabric on the sand to give us plenty of room to enjoy our tea. Then we will overlay the fabric with a white satin tablecloth. A vintage side table with mosaic top will hold our silver tea tray steady as we pour. This little table is quite old and showing much wear, but it has gone on many tea excursions with me, sometimes draped with a cloth, and sometimes left bare to let its age and character show.

The vintage silver teapot, creamer, sugar, and candelabra are the same ones we took with us on our cruise tea a few chapters ago. I love the way the silver reflects the sky and the brilliant rays of the setting sun. We will use an extra sugar bowl as a vase to hold these sparkling white iceberg roses I found in the grocery store. Our three-tier server draped with garlands of crystal-clear beads and prisms will beautifully hold our savories for today's teatime.

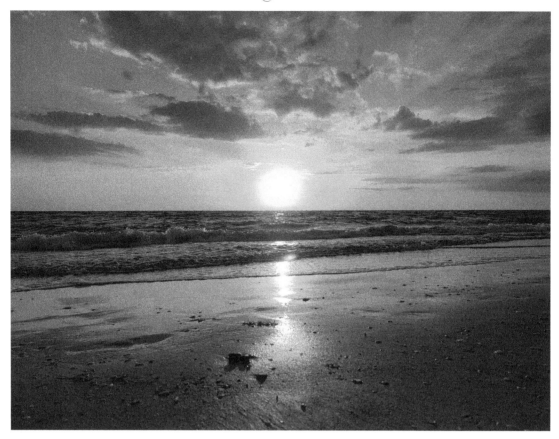

Cucumber is always refreshing and makes a perfect base for garden vegetable cream cheese topped with thin slices of salmon garnished with a sprig of dill.

The middle tier holds crunchy phyllo cups filled with a tangy seafood salad that is made with imitation crab and fresh herbs tossed with a creamy lemon dressing. The phyllo cups alternate on the middle tier with cool slices of bright orange starfruit. Amazingly, there are no seabirds around this evening, so our scrumptious fare is safe from uninvited avian guests.

Since this is a sunset tea to celebrate an anticipated wedding reunion, I have perched two white doves on the top tier. And of course, we have a cake. I chose a chocolate cake covered in white icing, dripping with a hard chocolate coating, and I topped our cake with some of the same iceberg roses that appear on our tea table.

Now that we are all set up, find a comfortable spot on the blanket next to the food, and I will pour a cup of Earl Grey tea for you. The sun is getting low, and the sky is beginning to glow. It's that golden hour, and here on the Gulf of Mexico, we have sunsets to swoon over. As the sun begins to look as if it is touching the water, the crimson reds and pinks gild the sky with spectacular color. Let's sit quietly for a few moments and take in the beauty and splendor of God's glorious creation. In the quiet, we can hear the gentle lapping of the waves and notice the fin of a young dolphin playing just beyond the surf. These teatimes with you have been so special, and I hope you have enjoyed every one of them.

As the sun gets lower, it's time to cut the cake and enjoy its sweetness with another cup of tea. By now, I'm sure, you're wondering whose wedding reunion we are anticipating. It's yours! If Jesus Christ is your Savior, if you believe His Word, that He is returning for His church, then as the Bride of Christ you are anticipating that glorious reunion. As we watch the sun set and gaze at the beautiful sky, let's enjoy a piece of cake with our tea and share with one another the promises He gave us of His glorious return.

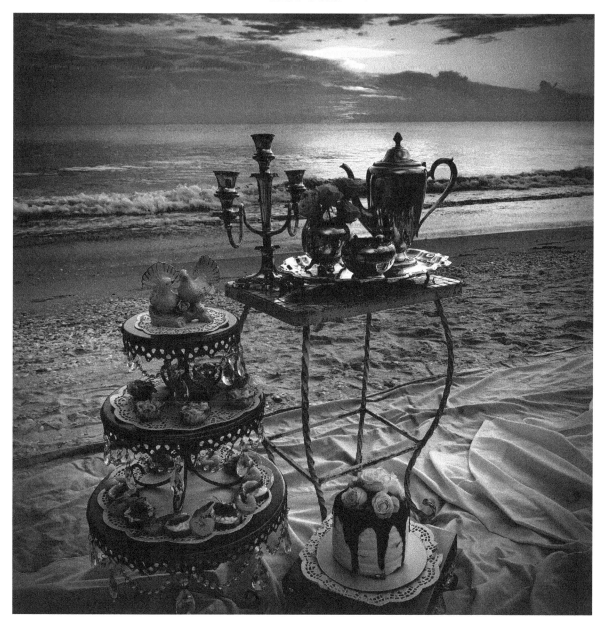

From the rising of the sun unto the going down of the same the Lord's name is to be praised.

— Psalm 113:3, KJV

Waiting with Expectancy

A skinny twelve-year-old girl squirmed her way through a crowd that was gathered to watch a giant white tent being set up in an empty field. The deafening sound of huge fans blowing air into the fabric structure made it nearly impossible to hear the conversation of anyone standing in the crowd watching this unusual sight. Signs were posted all around the tent listing dates of an event to take place in this unusual structure in just a few days. As she joined her parents and a few friends on the other side of the tent, they all agreed to return on the opening night and see what the excitement was all about. Over the next few days, curiosity and anticipation mounted around town, and everyone began discussing what it would be like to attend this "bubble tent revival," as it was called.

She had been to her local church and attended Sunday School all of her young life. She loved Jesus and loved hearing the Bible stories of God's love for her, but something about this tent being set up filled her with a sense of expectancy. When the opening day arrived, her mother made sure to gather everyone into the car and arrive at the site before the service started. It was an evening service, just before sunset, and upon arrival they saw massive crowds waiting outside the entry of the tent. Familiar church hymns could be heard inside, which only added to the sense of expectation. Her heart began beating with excitement before she even stepped in the door. As her turn came to walk through the entry

into the tent, a massive whoosh of forceful air from the big inflation fans rushed into her face and blew her hair straight back with more force than she expected. Once inside, the air was calm and comfortable, and only the low hum of the fans could be heard as she took her seat and looked up at the fabric ceiling of that giant white tent.

I remember that day as if it was yesterday. Yes, I was that skinny twelve-year-old, and that evening in the big white bubble revival tent changed my life. I don't remember who the speaker was, but I remember that from the first word he spoke my spirit was in a state of readiness with a sense of expectation that I didn't fully understand. The speaker talked of Jesus and familiar Bible scriptures that I had heard many times, but as that hour went on, I sensed that it would culminate in something important and life-changing for me, and I could hardly wait.

As the speaker began to draw the evening to a conclusion, he started describing the Second Coming of Jesus and his descriptions had me sitting on the edge of my seat. He read the scriptures from the Bible about the return of Christ in the clouds, and how He was the Bridegroom coming to gather His Bride to be with Him forever. He described the return of Jesus with such descriptive and anointed words that I imagine every person in that tent wanted to be sure they would be counted in that great event.

209

And then the music started. I remember they were playing the hymn "Just As I Am," and as I sang the words of that song, a powerful recognition of my sins and my need for Jesus to be my Savior flooded my soul. Tears streamed down my face with every word I sang, and soon I found myself flying out of my seat and rushing down the center isle of that tent to the altar to pray and fully give my life to Jesus as my Savior.

The next day, I was so full of anticipation of Jesus coming back that I kept looking up to the sky. I examined the clouds every time I was outside, and I wondered, "Is this the day Jesus will come back?" As the years went on and I grew older and busier with life, that breathless anticipation mellowed. Occasionally I would look up to the sky and wonder if this was the day of His return, but for the most part, the cares of life clouded my anticipation. Oh, I continued to love my Savior, and I continued to read His Word, spend time in His presence, and grow in faith, but that excited anticipation that His return could be any day wasn't there like it had been in the beginning.

I think most of us will admit the same thing. But you know what? He IS coming back! He told us He would, and we know it's closer today than it has ever been before. We don't have to be prophecy experts to know in our spirit how very close we are to hearing the trumpet sound and our Holy Lord return to Earth to claim His children. It's time for all of us to rediscover the Bible promises about the Second Coming of Jesus and rekindle our anticipation of His soon return.

I have an oil lamp fashioned similar to the ones used in Bible times. It was made in Israel, and I am lighting it for all of us today, as we read these scriptures and remind ourselves to watch for His promised return.

One of my favorites is the parable Jesus told comparing Himself to a bridegroom. In this parable, He reminds us to stay prepared for His return. "*At that time the kingdom of heaven will be like ten virgins who took their lamps and went out to meet the bridegroom. Five of them were foolish and five were wise. The foolish ones took their lamps but did not take any oil with them. The wise ones, however, took oil in jars along with their lamps. The bridegroom was a long time in coming and they all became drowsy and fell asleep. At midnight the cry rang out:" Here's the bridegroom! Come out to meet him!*" (Matthew 25:1-6, NIV).

The parable goes on to say that the ones who were not prepared missed the call of the bridegroom, but the ones who kept oil in their lamps and stayed in a state of anticipation heard the call of the bridegroom and were prepared to meet him. The oil represents so many things, more than I could fully understand or write about, but we do know that the oil represents being filled with the Holy Spirit. It also represents staying in a state of readiness. Jesus concluded this parable by saying "*Therefore keep watch, because you do not know the day or the hour*" (Matthew 25:13, NIV).

What are we to be doing while we "keep watch" and wait in a state of preparedness? I think the Bible makes it clear to us that we are to keep hope and keep our eyes on the goal. "*While we look forward with hope to that wonderful day when the glory of our great God and Savior, Jesus Christ, will be revealed*" (Titus 2:13, NLT).

- He wants us to love one another while we wait: *"This is His commandment: We must believe in the name of His Son, Jesus Christ, and love one another, just as He commanded us"* (1 John 3:23, NLT).

- Jesus also showed us that we should actually pray for His return. He taught us to ask for His return in the Lord's Prayer, when He taught us to pray, *"Thy Kingdom come"* (Matthew 6:10, KJV).

- He wants us to live holy and godly lives while we wait for His return: *"You ought to live holy and godly lives as you look forward to the day of God and speed its coming"* (2 Peter 3:11-12, NIV).

- Jesus tells us that He wants us to always keep watch. He wants us to keep a sense of anticipation that it could be any day. *"Therefore, keep watch, because you do not know on what day your Lord will come"* (Matthew 24:42, NIV).

- He wants us to use whatever gifts He has given us to worship Him and serve others while we wait, and to use those gifts to proclaim His Gospel to those who don't know Him: *"As each has received a gift, use it to serve one another, as good stewards of God's varied grace"* (1 Peter 4:10, ESV). *"For this reason I remind you to fan into flame the gift of God, which is in you"* (2 Timothy 1:6, ESV).

My friends, as we quietly sit gazing at this glorious sunset with its luminous clouds covering the sky, it's a great time to ponder our Lord's promise of His Second Coming and allow the Holy Spirit to fan into flame our longing for Him to return. Look at this beautiful sky and think, "What will it be like to see Jesus come in all His glory, to hear the trump of God and hear the host of thousands of angels crying "Holy, Holy, Holy?" It's a day we all should be thinking about and longing for.

I love the way the Message translation describes this glorious event: *"Then, the arrival of the Son of Man! It will fill the skies—no one will miss it. Unready people all over the world, outsiders to the splendor and power, will raise a huge lament as they watch the Son of Man blazing out of heaven. At that same moment, He'll dispatch his angels with a trumpet-blast summons, pulling in God's chosen from the four winds, from pole to pole"* (Matthew 24:30, MSG).

Let me encourage and motivate you by using the same words the apostle Peter used: *"And so, dear friends, while you are waiting for these things to happen, make every effort to be found living peaceful lives that are pure and blameless in His sight. And remember, our Lord's patience gives people time to be saved"* (2 Peter 3:14-15, NLT).

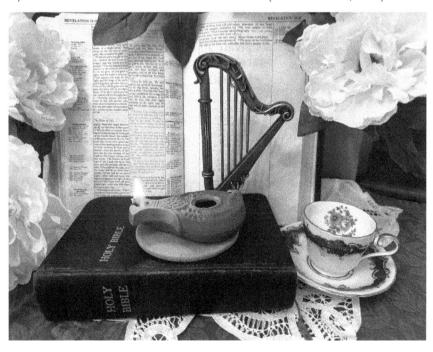

Therefore encourage one another and build one another up, just as you are doing.
–1 Thessalonians 5:11, ESV

PRAYER: Heavenly Father, You and You alone are holy. I take a moment to slow down and worship You. I ask that Your Holy Spirit revive me and rekindle in me a great excitement and anticipation of Your soon return to gather Your own unto Yourself. Thank You, Lord, that You forgave my sins and provided my salvation that I might know You are coming back for me.

CALL TO ACTION: Be sure to find your Bible and look up the scriptures below and meditate on the promises of the return of Jesus Christ to Earth.

FOR FURTHER ENCOURAGEMENT: Acts 1:10-11, Revelations 1:7, Hebrews 9:28, 1 Thessalonians 2:19-20, Romans 13:11, and 2 Peter 3:13

Write here something about your own salvation experience.

On this page is an invitation to worship with my daughters through dance and harp music. The worship dance by Tamara Grundy is to the song *What Do I Know of Holy* by Addison Road. In this dance, Tamara invites you to contemplate just how powerful and holy God is. The harp music by Janelle Varnes is played live on the beach, as she reads Bible scriptures about God's healing power while you watch the waves gently roll in the background. May you sense God's presence as you worship.

Keep yourselves in God's love as you wait for the
mercy of our Lord Jesus Christ
to bring you to eternal life.
Jude 1:21, NIV

He who testifies to these things says,
"Yes, I am coming soon."
Amen. Come, Lord Jesus.
– Revelation 22:20, NIV

We wait for the blessed hope–
the appearing of the glory of our great
God and Savior, Jesus Christ,
– Titus 2:13, NIV

A Word from the Author

If you picked up this book because you love beautiful teacups and enjoy teatime, but you don't know Jesus as your Savior, I'd like to personally invite you to hear my heart's plea to come to know the One who created you and loves you with a perfect, unconditional, and everlasting love.

If I could sit over a cup of tea with you right now, I would remind you that He had you in mind before you were created and that He knows everything about you. I would show you the scriptures that tell you how Jesus Christ, the Son of the living God, loved you so much that He stepped down from Heaven to walk this Earth to reveal the heavenly Father's love for you. I want you to know the depth of His love and realize that He voluntarily sacrificed His life that you might have the free gift of eternal life. *"For God so loved the world that He gave His only Son that whosoever believes in Him should not perish but have eternal life"* (John 3:16, ESV). He paid the price for you to live forever in His presence.

If you're not personally acquainted with the Lover of Your Soul, He said that if you seek Him with all your heart, you will find Him. *"You will seek me and find me when you seek me with all your heart"* (Jeremiah 29:13, NIV). He promised to guide you through this life, provide your needs, comfort you when you need comforted, and said that He would never leave you or forsake you.

I've known and walked with the Lord Jesus Christ since giving my life to Him as a young girl, and discovering the depth of my Savior's love for me continues to be a lifelong journey. I invite you to experience this journey along with me and all those who return the Savior's love.

Almost everyone has a Bible, but not everyone reads it. The Bible is God's love letter to you. Read it with an open heart and ask Him to reveal its truth to your spirit. To get started on your journey with the Savior, begin by reading the book of John. It reveals His love for you in a powerful way. You need only believe His Word and trust Him to lead you every step of the way, as you walk with Him.

I have been thrilled that you enjoyed these teatime devotions with me. I hope you feel inspired to look at the events in your life and see all the many ways God reveals Himself to you. It is my desire that you realize how very much God loves you and that He speaks to you of His love and faithfulness through His Holy Word, the Bible, and reveals Himself to you every day.

So, gather some friends for tea, share your testimony of coming to belief in Him, tell your faith-filled stories to each other, and spread the seeds of faith!

If you desire to contact me, I would love to hear from you.

Proclaiming God's Faithfulness,
Sherri House
PO Box 7376
Naples, FL 34101

Email: Sherri@teawithjesusandme.com

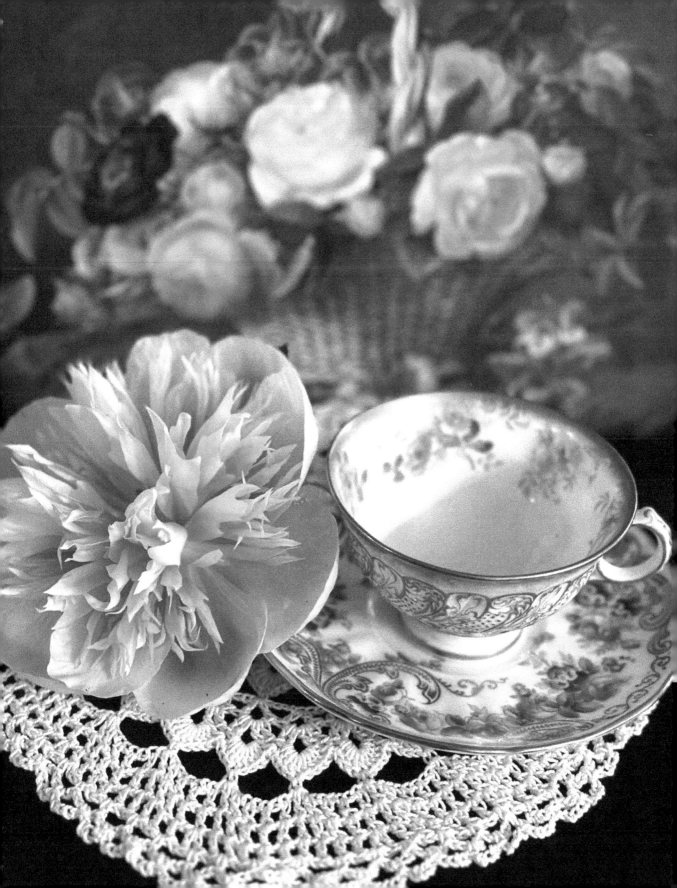

Printed in the USA
CPSIA information can be obtained
at www.ICGtesting.com
LVHW072338111024
793587LV00021B/579